Reflections at Sandhill Creek

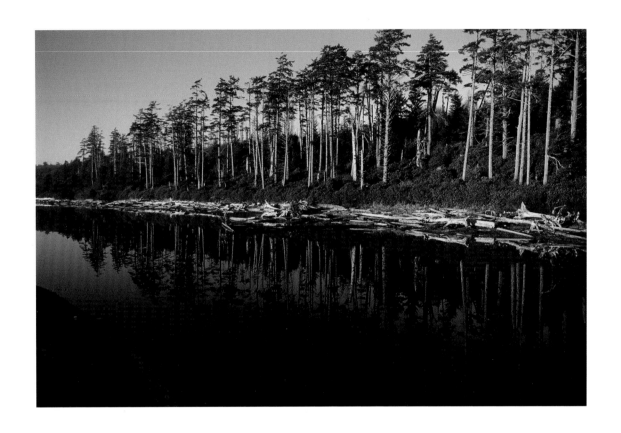

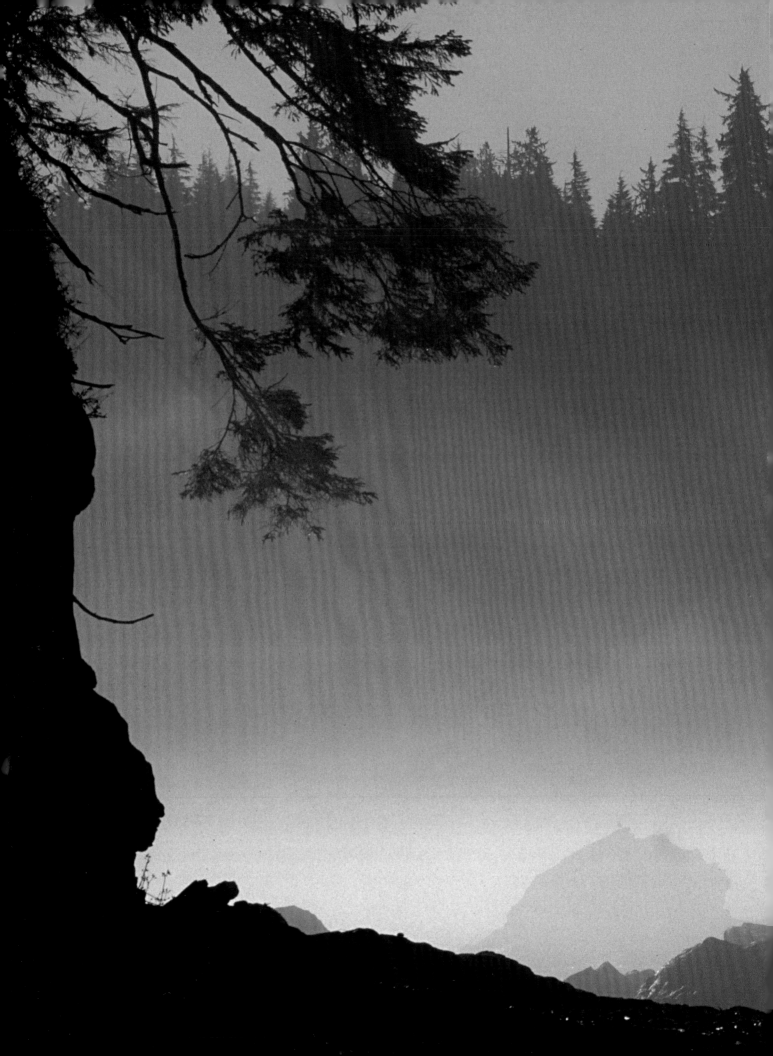

Reflections at Sandhill Creek

Adrian Dorst

Harbour Publishing

Preface

The title of this book derives from a time three decades ago, when I lived near the mouth of Sandhill Creek, which empties onto Long Beach on Vancouver Island. Here I sought to escape the usual trials and travails of the world to seek peace and understanding through meditation in nature. Over a two-year period I spent untold hours hiking the beaches, sitting amongst the driftwood logs, and otherwise immersing myself in the natural world. With few distractions other than the roar of the surf, the cries of eagles and gulls, and the comings and goings of migratory birds, I embraced solitude and quiet contemplation. During the long winter evenings, if I was not simply listening to the howling wind and the rain pounding on my camper roof, I would read books by the light of a lantern. At times, meaningful quotes would literally leap off the page, prompting me to copy them into a leather-bound notebook. This I did for no reason other than that they were helpful to me in my quest for understanding. Without realizing it then, that was the beginning of this book.

Adrian Dorst

For Henry
in loving memory

Introduction

The subtitle of this book could well have been *Meditations in Search of Self*, for the theme of this book is best expressed by quotes from two men, Hermann Hesse and Ralph Waldo Emerson. Hesse said, "Each man has only one genuine vocation—to find the way to himself." Emerson proclaimed, "The world exists for the education of each man."

Emerson, of course, was not using the word education in the sense it is most often used today—acquiring skills and knowledge for the purpose of furthering one's career. He was using the word in a much broader sense—to discover Truth and gain understanding about the world, life, and oneself. Emerson was well aware that true happiness in life is dependent on this. The writer Robertson Davies would have agreed. He once advised his graduating students, "I hope you won't bother your heads about happiness. It is a cat-like emotion; if you try to coax it, happiness will avoid you, but if you pay no attention to it, it will rub against your leg and spring unbidden into your lap. Forget happiness and pin your hopes on understanding."

Understanding, whether sought through direct experience or the written word, is elusive. The world of ideas, using language as symbols, is by its very nature interpretation, and truth must vie on equal footing with misinformation of all kinds. Manufacturers try to persuade us that we need their products in order to be happy, religious institutions pitch salvation through surrender to a deity, and scientists inadvertently stray into the realm of dogma by creating a box called "the known," then vigorously denying realities outside the box. Edward Abbey once observed, "That which today calls itself science, gives us more and more information, an indigestible glut of information, and less and less understanding." Science may have its place, but it is of little help in the realm of personal understanding.

The greatest obstacle to understanding, however, may be the everyday paradigm of conventional wisdom, which in effect defines for us what is "normal" and what is true, and which perpetuates the notion that the pursuit of material wealth will bring us happiness. Each person, therefore, must be prepared to determine what truth is for himself, or herself, alone. Recognizing this point is crucial for anyone on the road to self-discovery. "There is no authority but you," said Krishnamurti. "To be a man," said Emerson, "one must be a non-conformist." In other words, to become a complete and independent person, one must abandon the crowd and go one's own way.

There are no blueprints on life's path, no road maps, and our path through life only becomes visible on looking back. In human society, with its emphasis on status and wealth and security, it is all too easy to lose one's way, far removed from being true to one's own true nature. Henry David Thoreau wrote, "If a plant does not live according to its nature it dies, and so a man." A poet cannot find fulfillment as a mathematician, nor a mathematician as a poet. We are unique individuals, each and every one of us, and we owe it to ourselves to be true to that uniqueness. Not to do so is to rob ourselves of our inherent wealth, our happiness and our potential.

However, while we are unique, we also share a common foundation with all humanity. The ancient Chinese book *The I Ching* explains it this way: "However men may differ in disposition and education; the foundations of human nature are the same in everyone. And every human being can draw in the course of his education from the inexhaustible wellspring of the divine in man's nature."

While no one can provide us with a road map for our path through life, there are nevertheless many signposts available that provide guidance to those receptive enough to seek them out. These signposts are to be found in the writings of great men and women who through their observations came to recognize simple, but often elusive, truths. Foremost among these is that all movement in the universe, including our own, is governed by immutable natural laws. Albert Einstein once wrote, "Everything is determined by forces over which we have no control. It is determined for the insect, as well as for the star. Human beings, vegetables, cosmic dust—we all dance to a mysterious tune, intoned in the distance by an invisible piper." While we cannot control these forces, *The I Ching* informs us that "…by understanding the great laws of the universe we act in harmony with them."

The quotes selected for this book were chosen for no reason other than that they were meaningful to me personally. I encourage you to read them one at a time in a quiet place free from distractions. Absorb what you can and contem-

plate the rest, but if the significance of a quote eludes you, don't despair. "God shields us evermore from premature ideas," Emerson tells us. We may, in fact, not recognize the truth of a statement until after we have learned the lesson. However, left open as questions, the quotes can be as useful to you as answers. After all, only the inquiring mind has an open door. The mind that knows is closed.

The quotes are placed sparingly on the page for good reason. In a world in which we are bombarded with facts and information and surrounded by a multitude of distractions, we are in need of space to reflect and contemplate the deeper meaning of our lives. And what is space, after all, if not solitude? You will also notice that certain ideas are repeated, though in different words by different speakers. That too is no accident. I present them here as universal truths that have been observed by men and women over the ages. They are as relevant today as when they were written.

According to Taoist thought, the road to oneself, or "the way," is neither difficult nor easy, but it does require self-discipline and facing oneself. Hermann Hesse once wrote, "I realize today that nothing in the world is more distasteful to a man than to take the path that leads to himself." Hesse recognized that people will embrace every distraction under the sun in order to avoid facing themselves. In today's world, with its myriad forms of entertainment, (or busyness with work and daily activities) escape from oneself has never been easier. Ancient writings warn against this, modern ones rarely do.

The photographs in this book are from the west coast of Vancouver Island and are intended to place the reader in the same natural setting that has been my home and inspiration for the past thirty-five years. Many are from the Sandhill Creek area of Long Beach, while most of the others were taken among the islands of Clayoquot Sound. I still live in the area and these places continue to be a profound joy and inspiration to me.

You don't need to travel to Long Beach or Clayoquot Sound to find solitude, of course. In fact, if you were to seek out Sandhill Creek for yourself, you'd be missing the point. Instead, look for a place near your home where nature still dominates—if not a wild beach or a mountain wilderness, then a wooded valley, a country lane or even a city park. Walk alone. Immerse yourself in nature. Surrender to yourself. On the day you find yourself at one with the universe and with yourself, you will know that you are truly home and you will glow with an inner joy.

Lao-tsu wrote many centuries ago, "Those who talk, don't know, those who know, don't talk." This did not stop him from writing a book of his thoughts. Such is the paradox of attempting to convey truth. Keep that in mind when reading the quotes in this book. Either they will ignite a spark of recognition within you, or they won't. They are not intended to be gospel. If you are prepared to throw them to the wind as well as to see the truth behind them, you will approach them in the right spirit. Relax. Enjoy. Be happy.

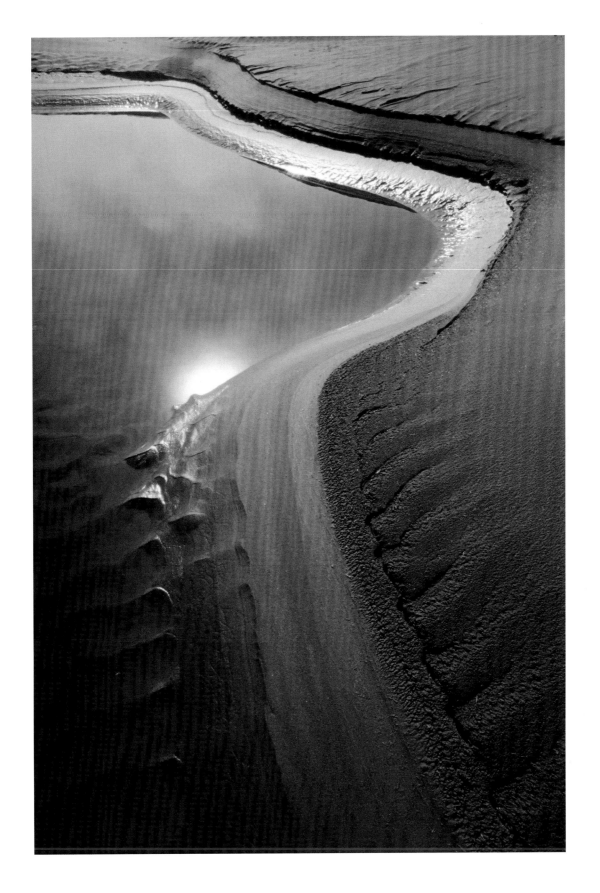

The world exists for the education
of each man.

RALPH WALDO EMERSON

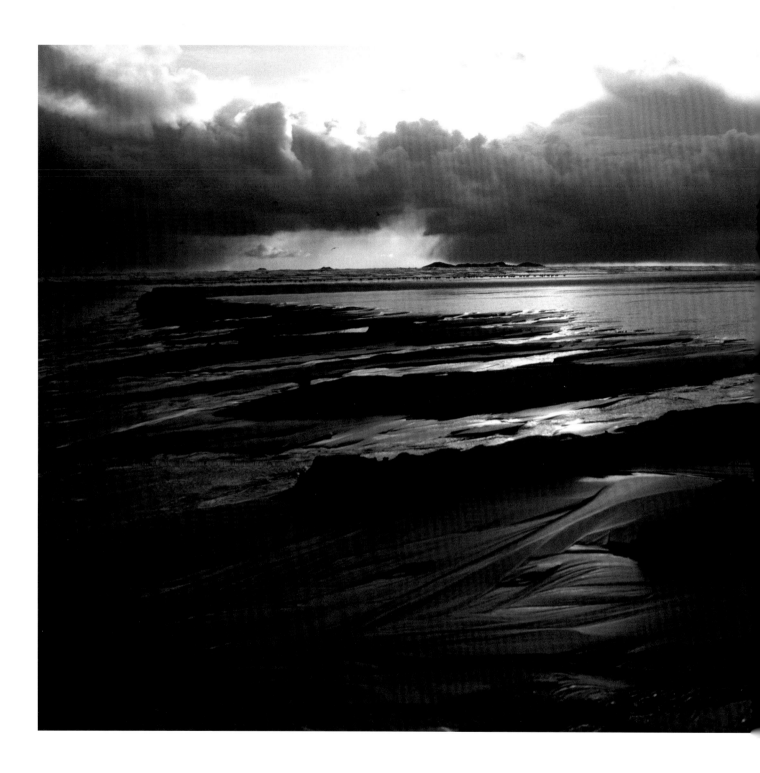

The earth is rude, silent, incomprehensible at first…
Be not discouraged, keep on, there are divine things
well envelop'd, I swear to you there are divine
things more beautiful than words can tell.

WALT WHITMAN



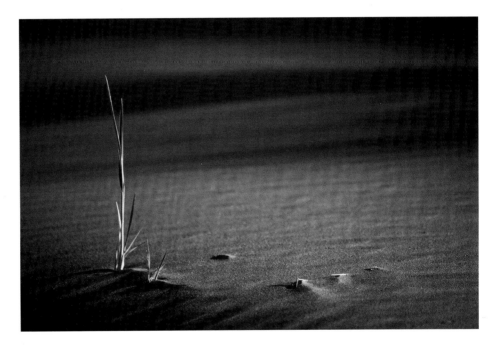

If a plant cannot live according to its nature,
it dies; and so a man.

HENRY DAVID THOREAU

Try to become not a man of success,
but try rather to become a man of value.

ALBERT EINSTEIN

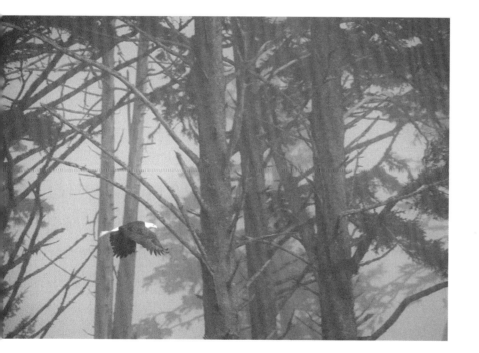

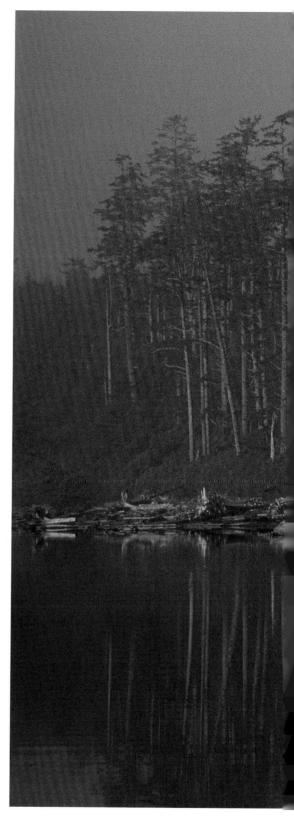

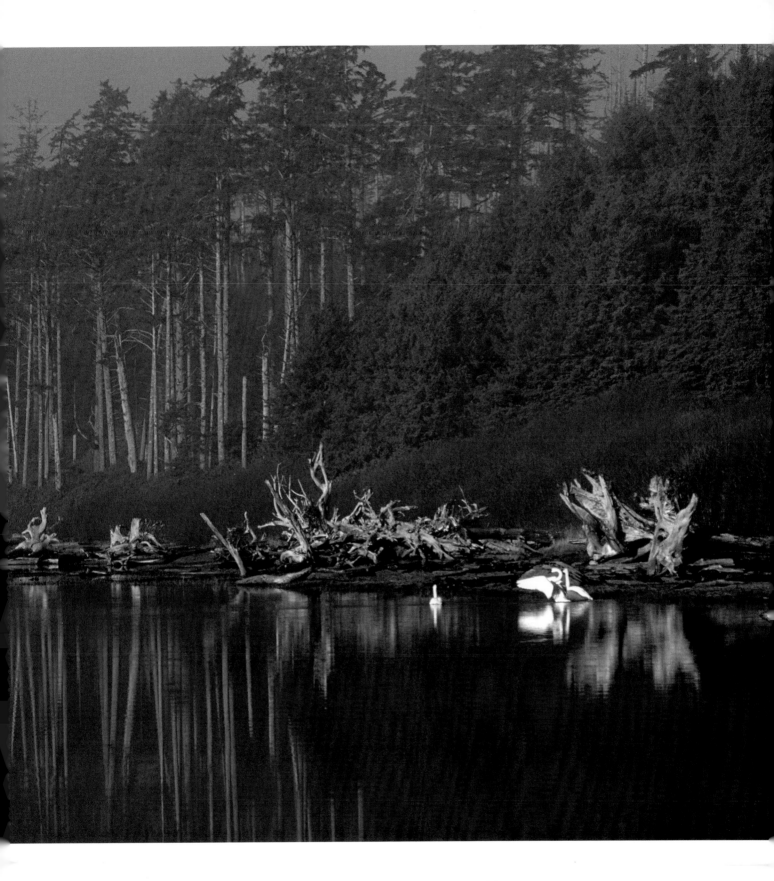

If a man wants to be of the greatest possible
value to his fellow creatures, let him begin the
long, solitary task of perfecting himself.

ROBERTSON DAVIES

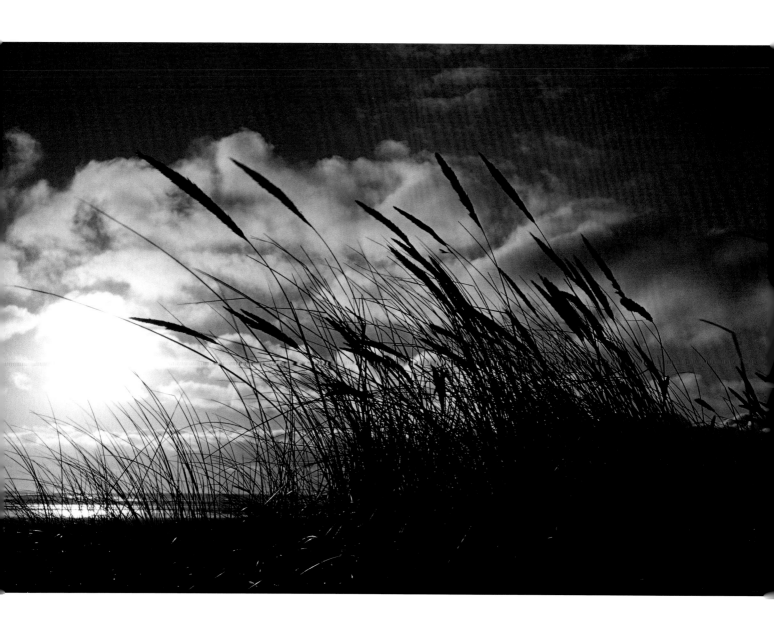

I count him braver who overcomes his desires than him who conquers his enemies;
for the hardest victory is the victory over self.

ARISTOTLE

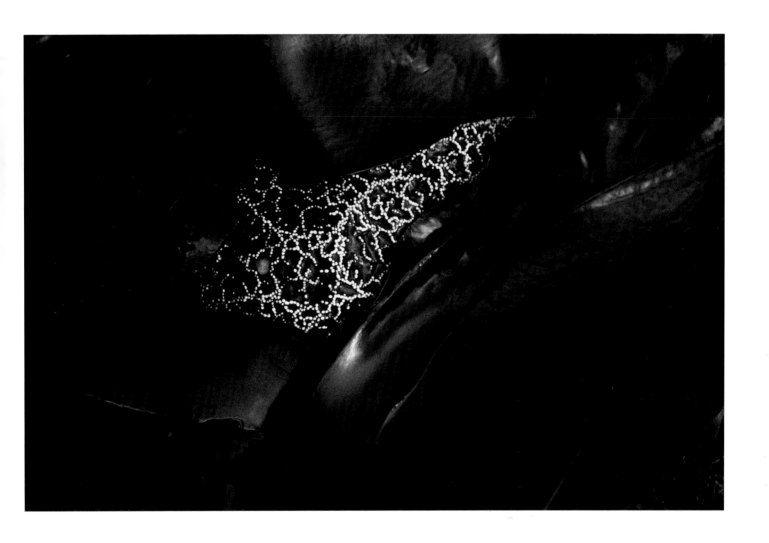

Each man has only one genuine vocation—
to find the way to himself.

HERMANN HESSE

…he not busy being born, is busy dying.

BOB DYLAN

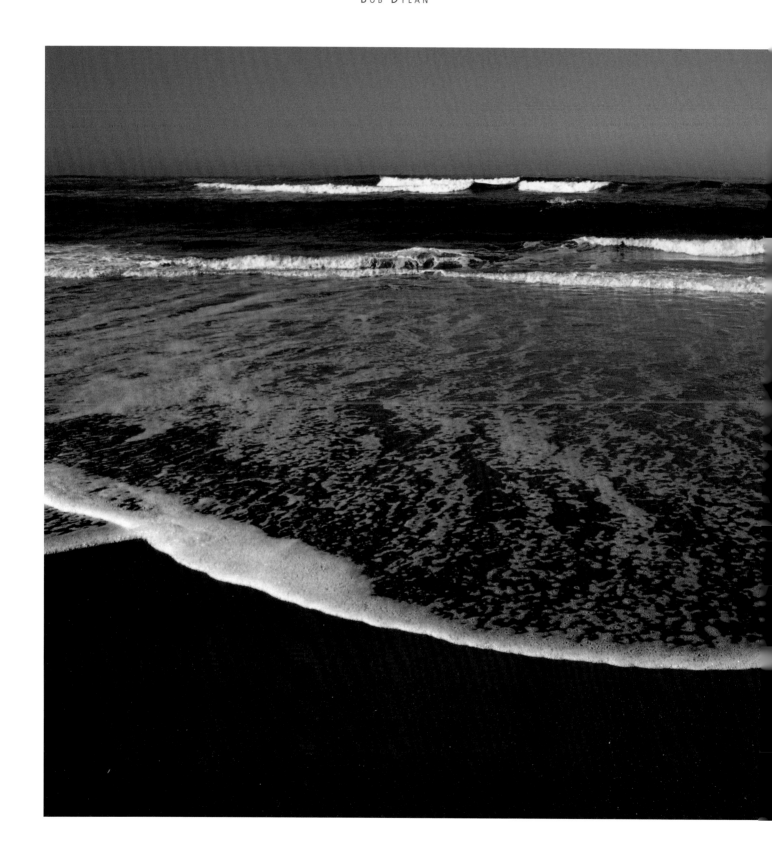

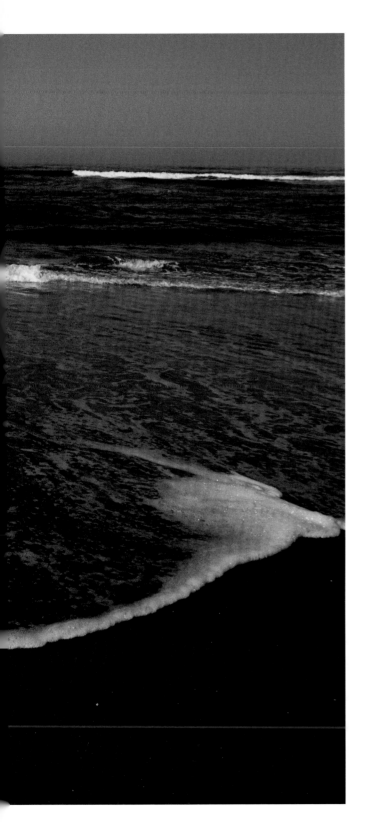

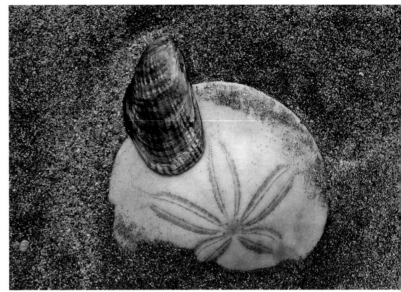

Whoso would be a man, must be
a nonconformist.

RALPH WALDO EMERSON

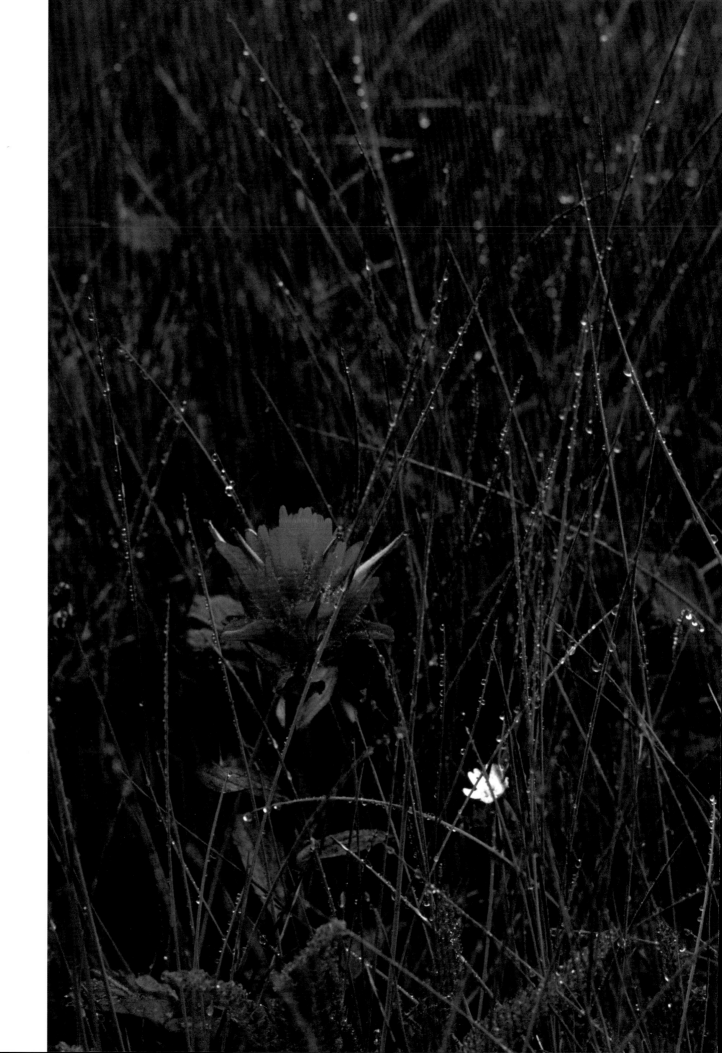

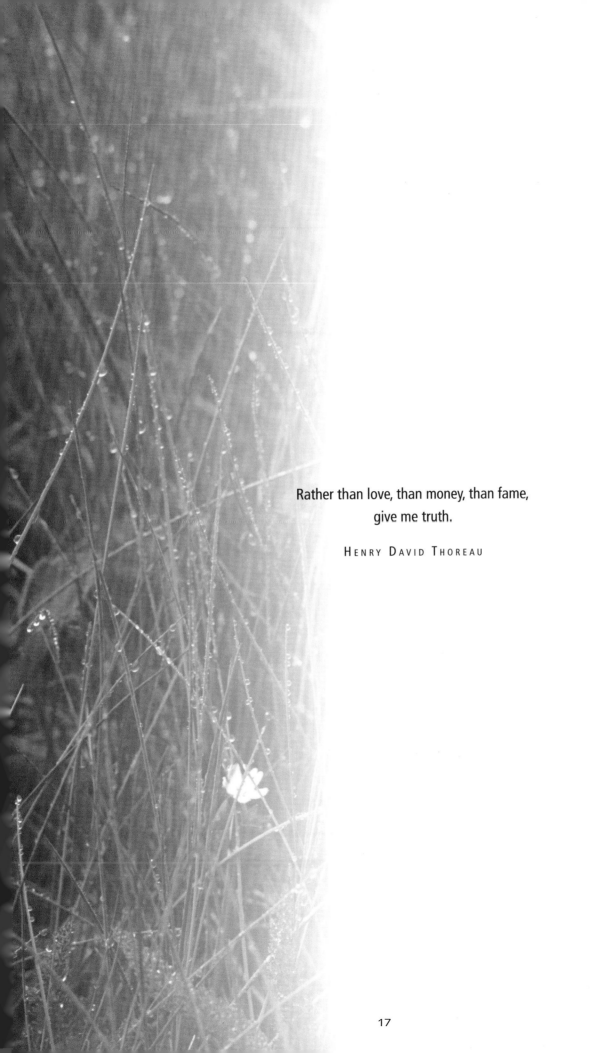

Rather than love, than money, than fame,
give me truth.

HENRY DAVID THOREAU

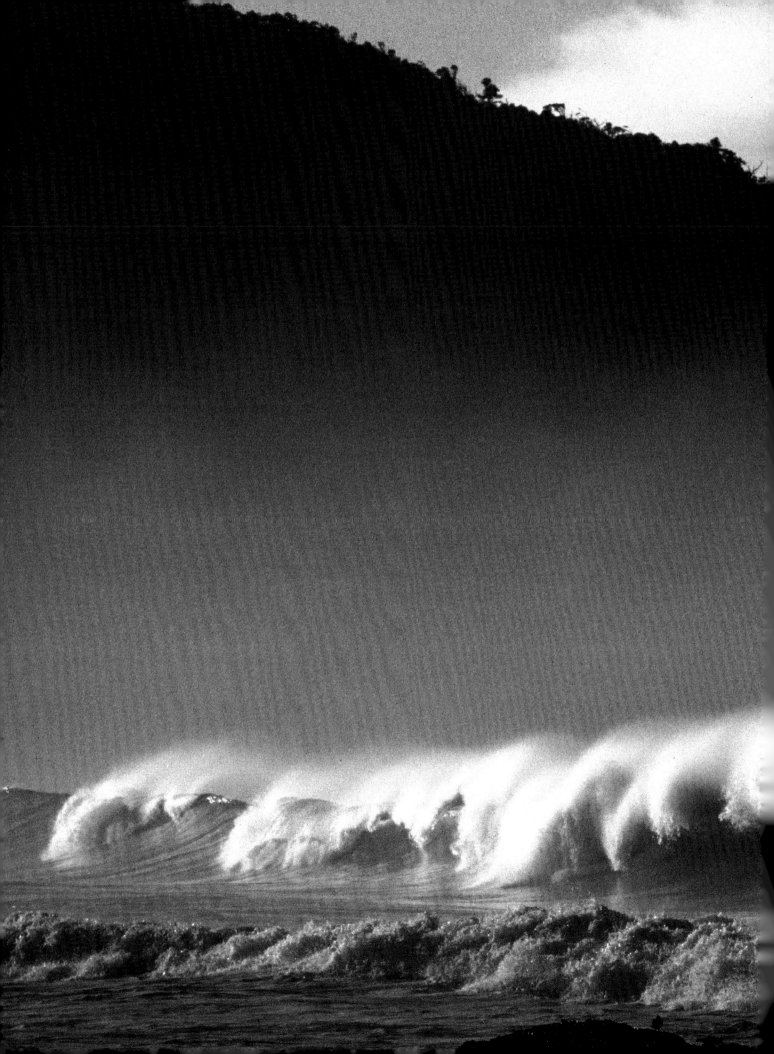

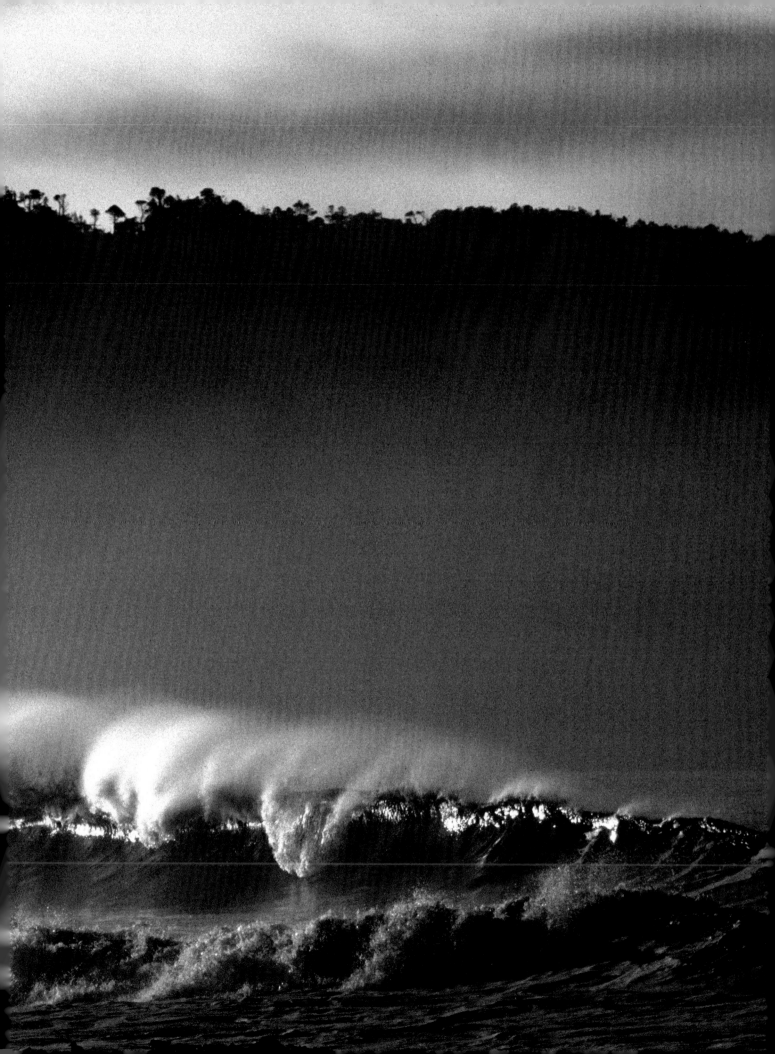

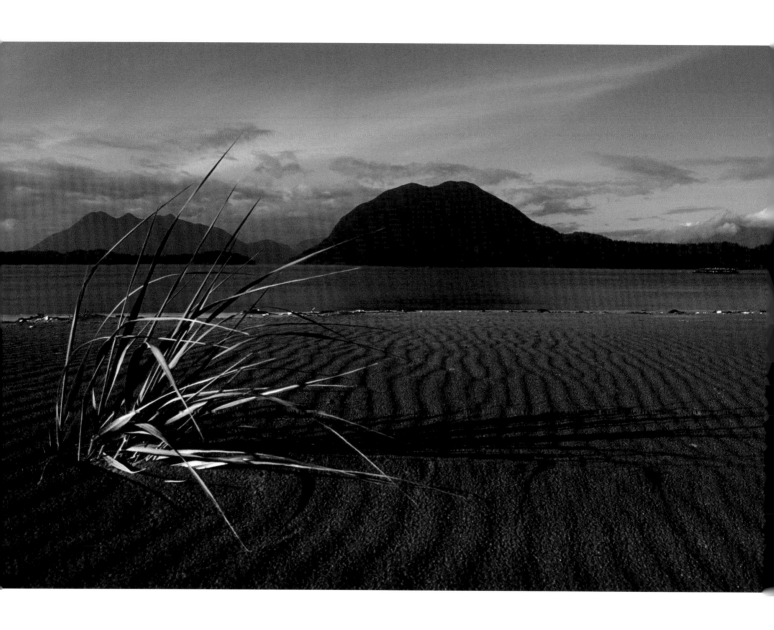

No man can learn what he has no preparation for learning,
however near to his eyes is the object. A chemist may tell his
most precious secrets to a carpenter, and he shall never be the
wiser… God screens us evermore from premature ideas.

RALPH WALDO EMERSON

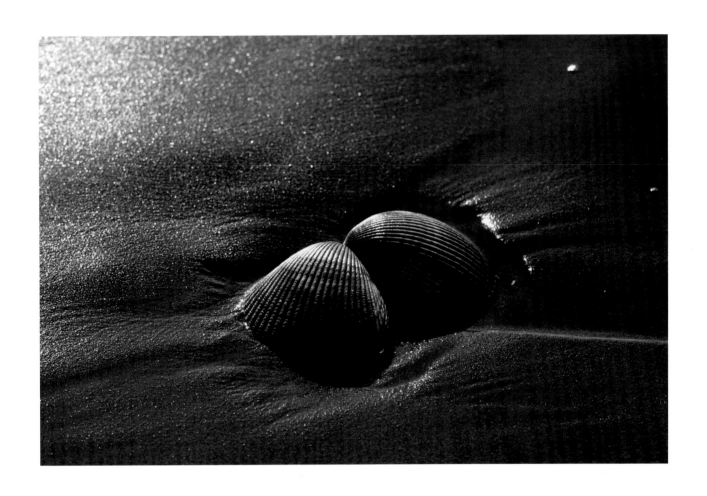

What we do not call education is more precious than
that which we call so.

RALPH WALDO EMERSON

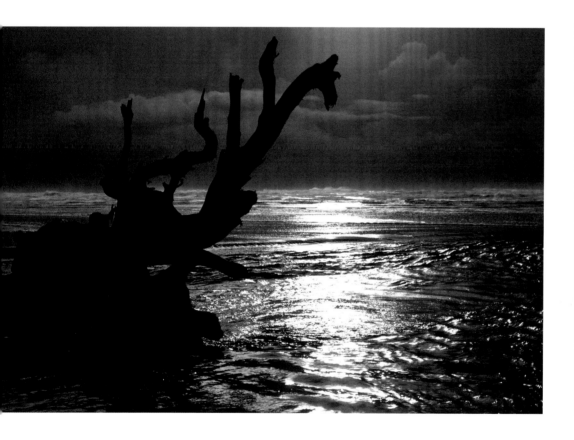

Re-examine all that you have been told…
dismiss that which insults your soul.

WALT WHITMAN

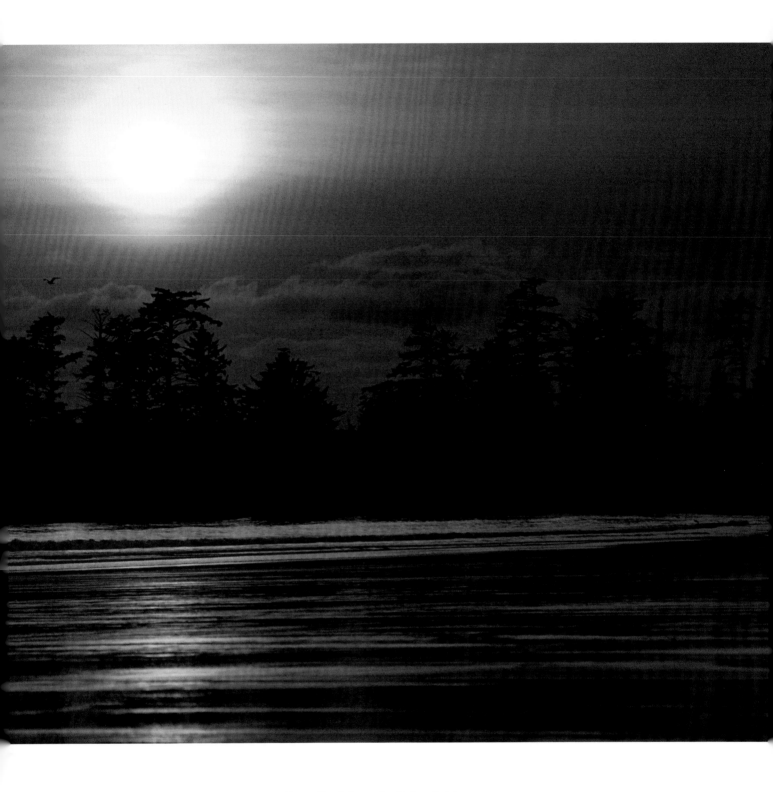

Come forth into the light of things.
Let nature be your teacher.

WILLIAM WORDSWORTH

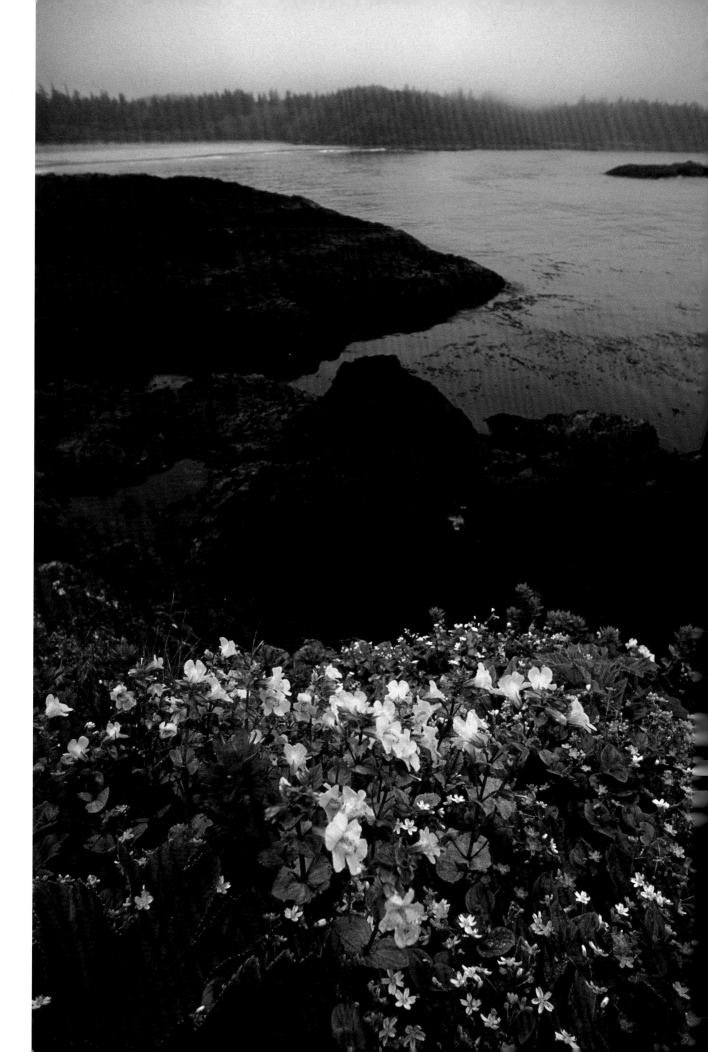

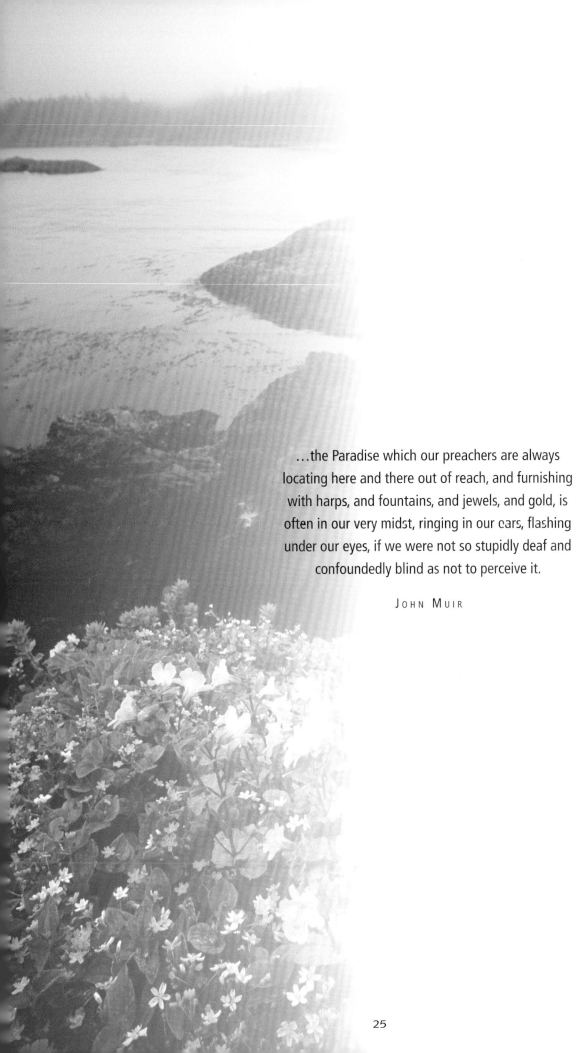

...the Paradise which our preachers are always
locating here and there out of reach, and furnishing
with harps, and fountains, and jewels, and gold, is
often in our very midst, ringing in our ears, flashing
under our eyes, if we were not so stupidly deaf and
confoundedly blind as not to perceive it.

JOHN MUIR

I wish you could come here and rest a year in
the simple unmingled love-fountains of God.
You would return with fresh truth gathered
and absorbed from pines and waters and
deep-singing winds…

JOHN MUIR

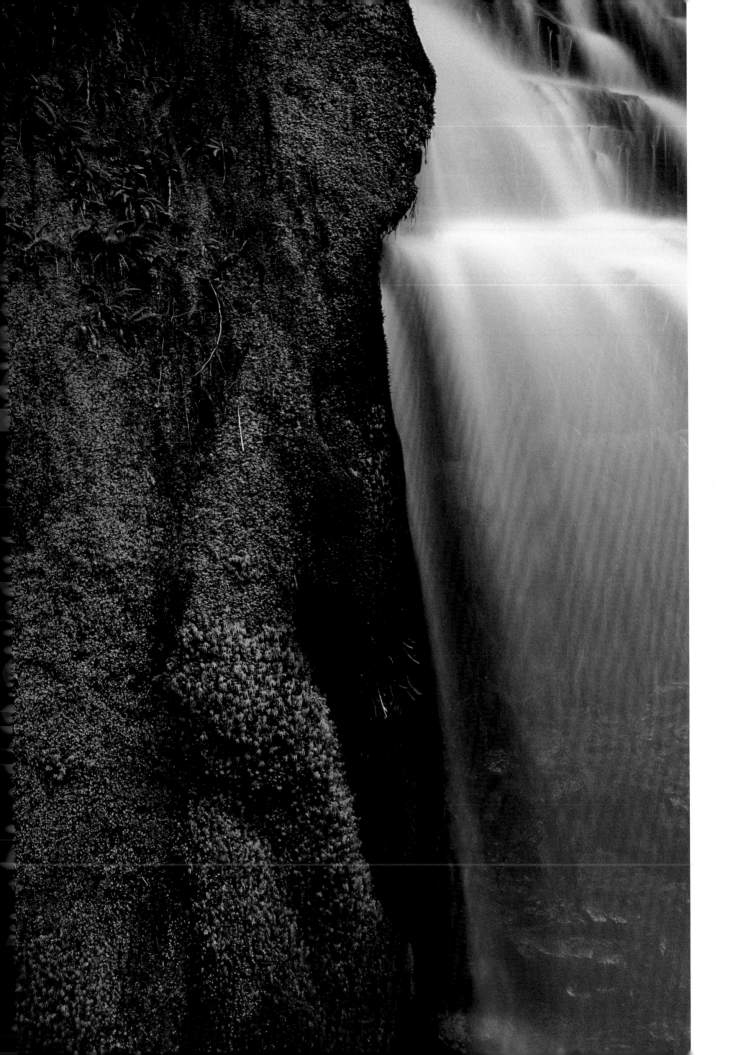

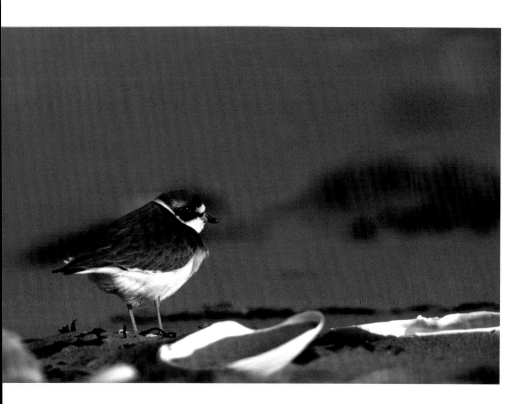

Little is needed to make a wise man happy,
but nothing can content a fool.

LA ROCHEFOUCAULD

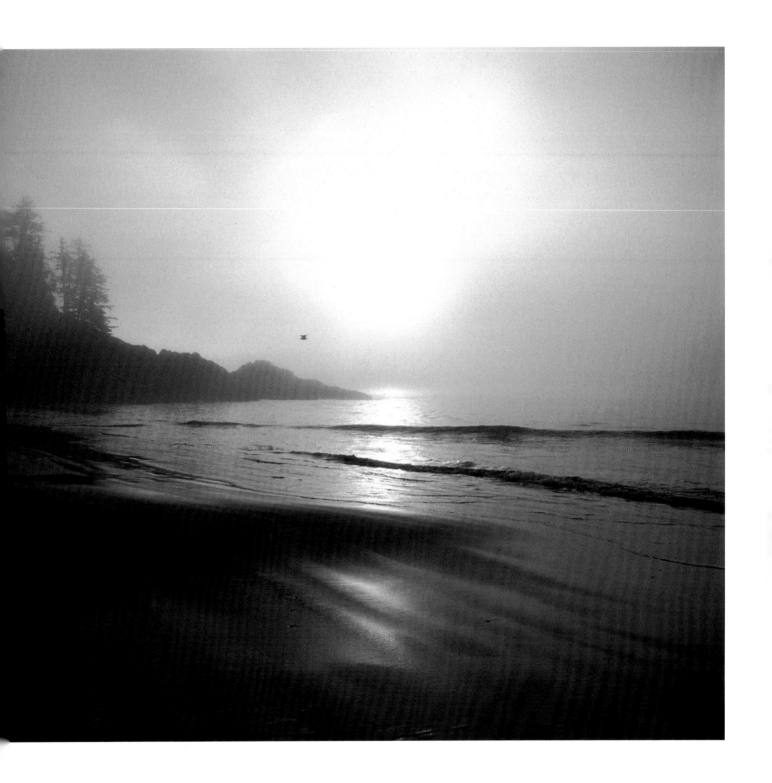

Whenever a mind is simple, and receives a divine wisdom,
old things pass away—means, teachers, texts, temples fall;
it lives now, and absorbs past and future into the present hour.

RALPH WALDO EMERSON

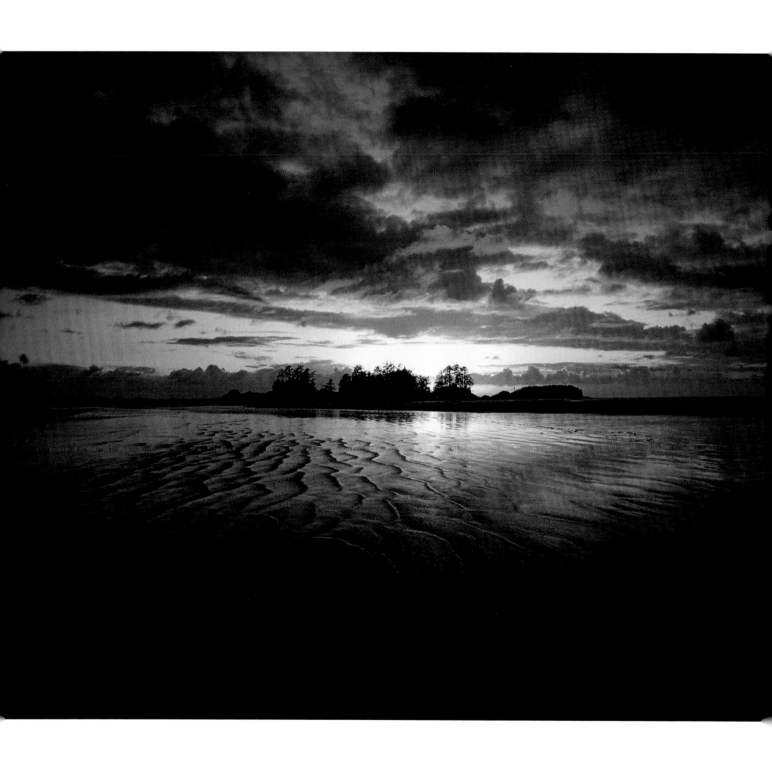

Give up the struggle and luminosity presents itself.

BARDO TÖDROL CHENMO

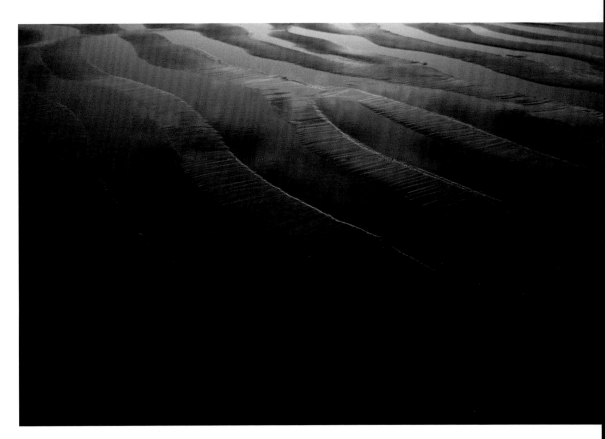

If you are too clever you could miss the point entirely.

A TIBETAN SAYING

I found I had less and
less to say, until finally,
I became silent, and
began to listen.
I discovered in the
silence, the voice of God.

S ØREN K IERKEGAARD

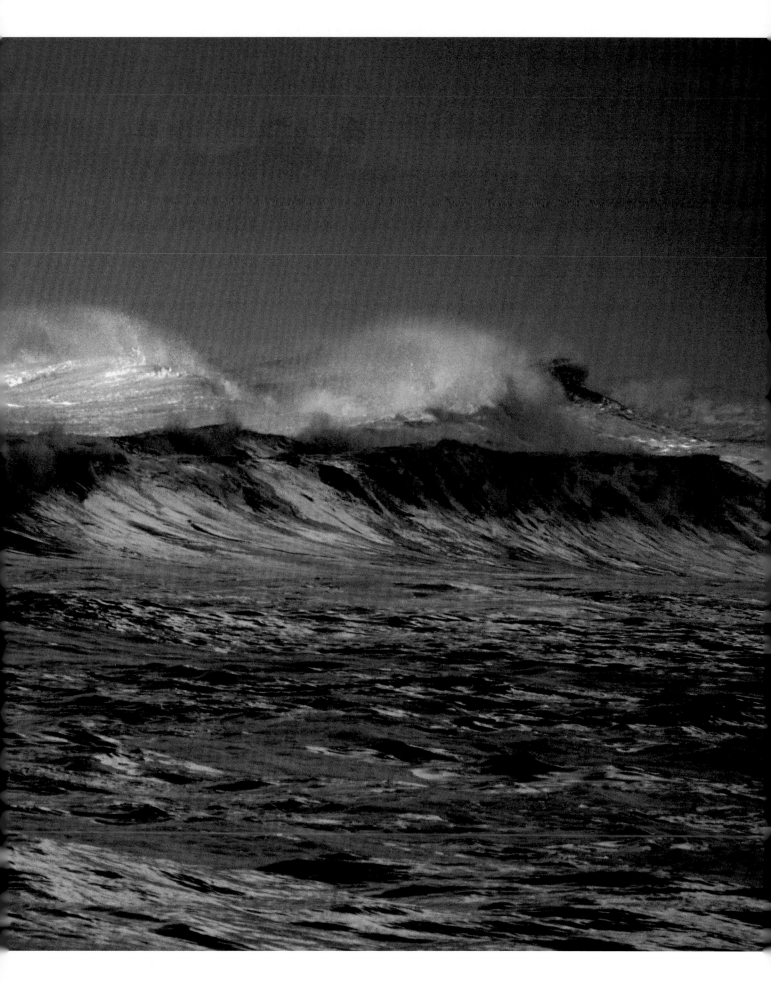

When a man has thus become calm, he may turn to the outside world. He no longer sees in it the struggle and tumult of individual beings, and therefore has that true peace of mind, which is needed for understanding the great laws of the universe and for acting in harmony with them. Whosoever acts from these deep levels makes no mistakes.

THE I CHING

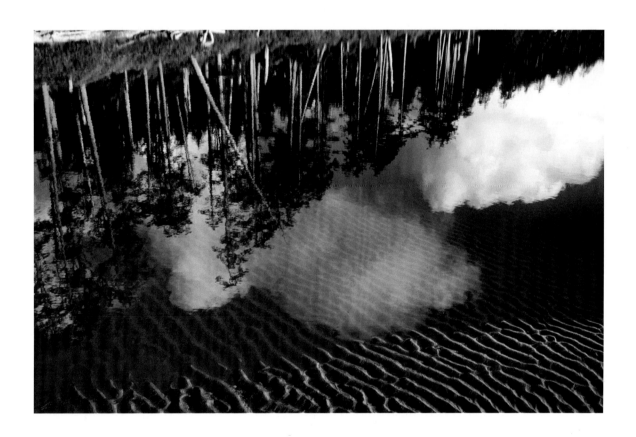

Only in quiet waters do things mirror themselves undistorted,
Only in a quiet mind is adequate perception of the world.

HANS MARGOLIUS

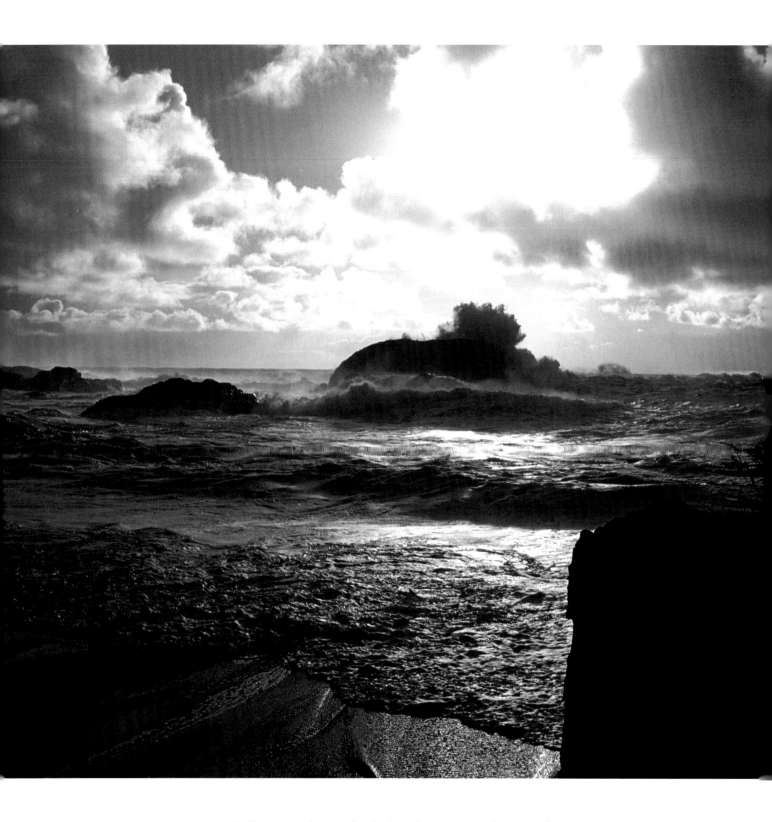

Ordinary men hate solitude. But the master makes use of it,
embracing his aloneness, realizing he is one with the universe.

Lao-tsu

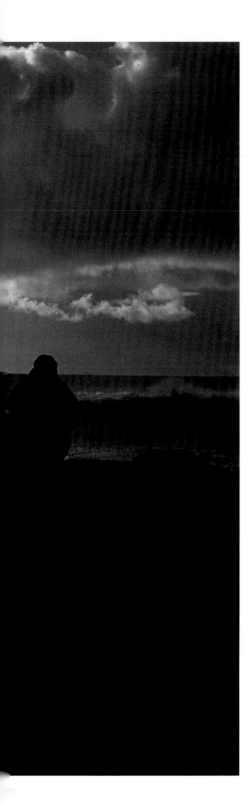

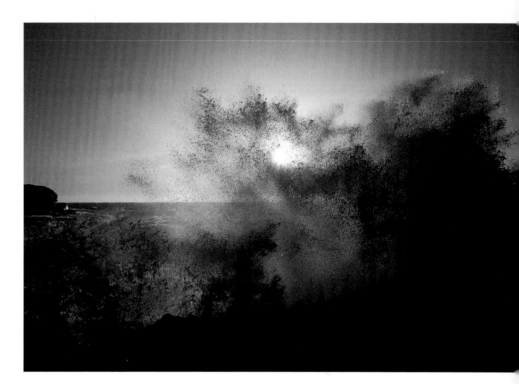

It is easy in the world to live after the world's opinion;
it is easy in solitude to live after our own; but the great man is he
who in the midst of the crowd keeps with perfect sweetness
the independence of solitude.

RALPH WALDO EMERSON

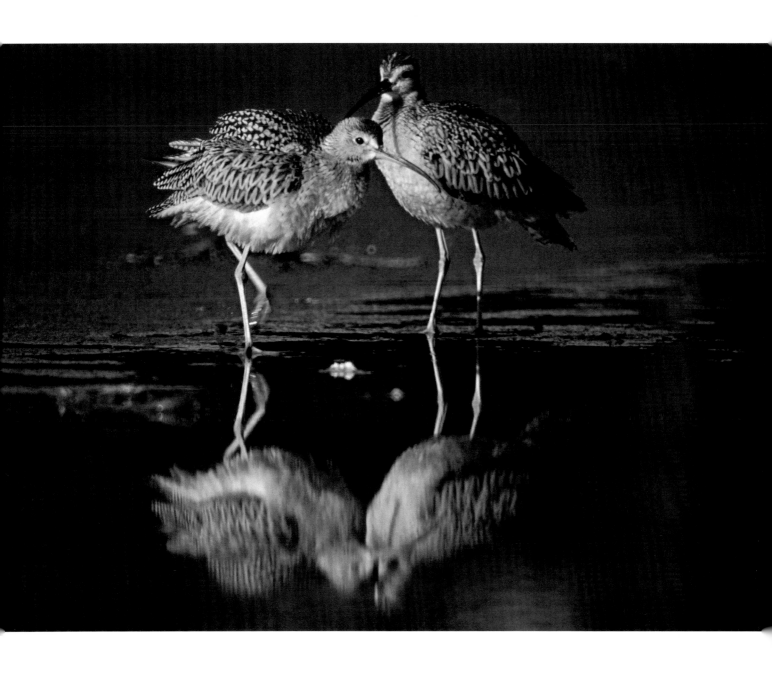

As you simplify your life, the laws of the universe will be simpler;
solitude will not be solitude, poverty will not be poverty,
nor weakness weakness.

HENRY DAVID THOREAU

It is in deep solitude that I find the gentleness with which
I can truly love my brothers. The more solitary I am,
the more affection I have for them....

THOMAS MERTON

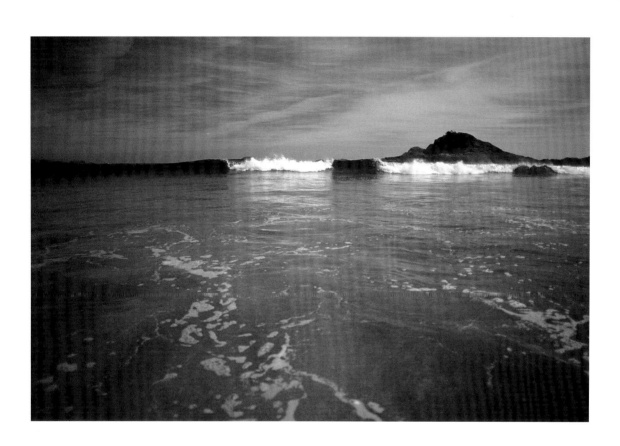

What man's law shall bind you if you break your yoke
but upon no man's prison door?
What laws shall you fear if you dance
but stumble against no man's iron chains?

Kahlil Gibran

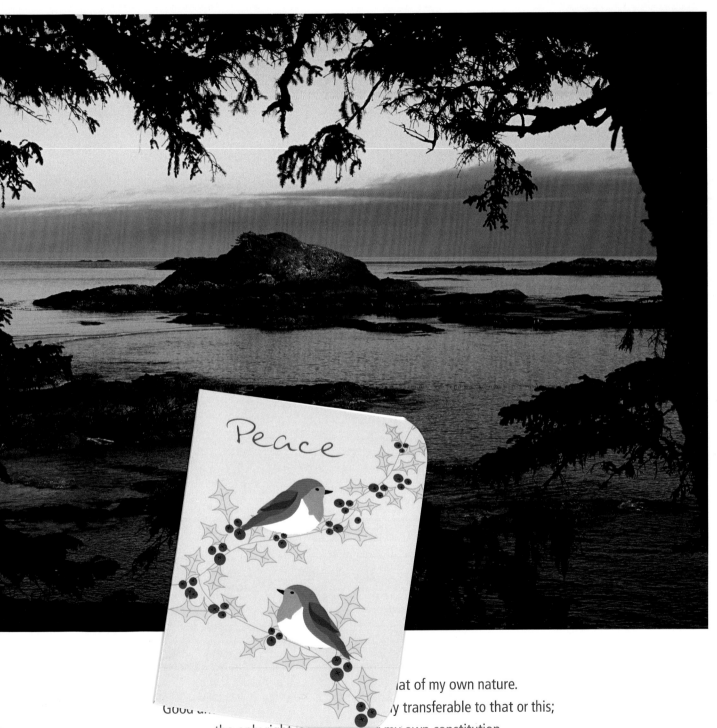

at of my own nature.
Good a... ...y transferable to that or this;
the only right is what is after my own constitution,
the only wrong what is against it.

RALPH WALDO EMERSON

Thy lot or portion of life is seeking after thee;
therefore be at rest from seeking after it.

THE CALIPH ALI

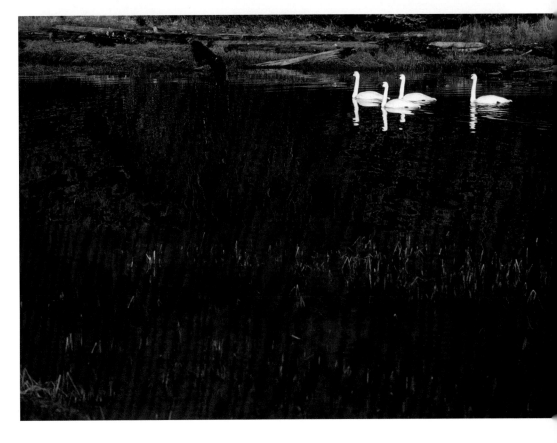

A true man never frets about his place in the world,
but just slides into it by the gravitation of his nature
and swings there as easily as a star.

EDWIN HUBBEL CHAPIN

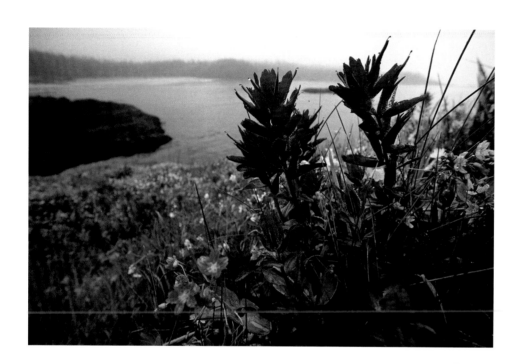

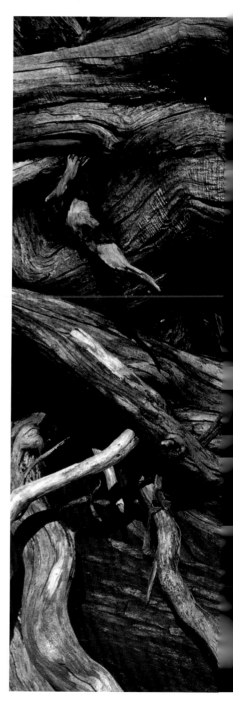

A little consideration of what takes place around us every day would
show us that a higher law than that of our will regulates events;
that our painful labours are very unnecessary and altogether fruitless;
that only in our easy, simple, spontaneous action are we strong,
and only by contenting ourselves with obedience we become divine.

RALPH WALDO EMERSON

If a magnetic needle, a strip or particle of iron be shown its way,

shall the soul of a free man be left unguided?

…we are governed more than we know, and most when we are wildest.

JOHN MUIR

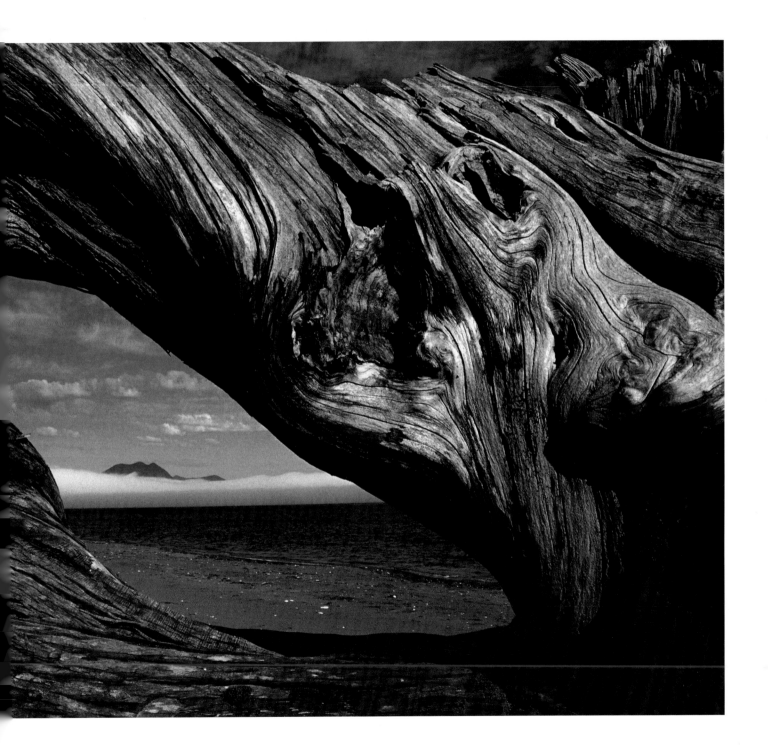

The goal of life is to make your heartbeat match
the beat of the universe, to match your nature
with Nature …

JOSEPH CAMPBELL

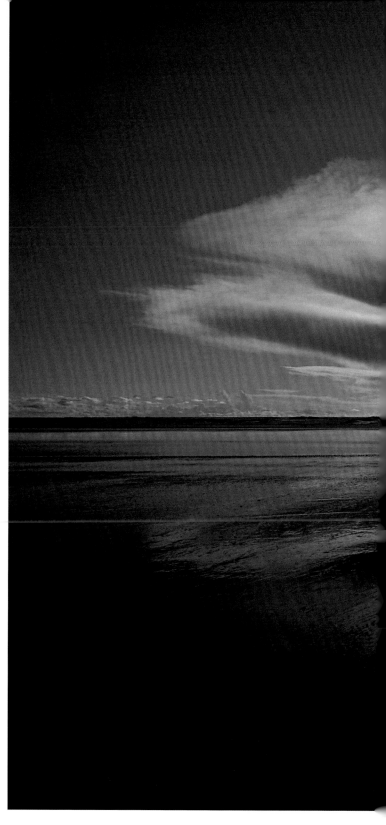

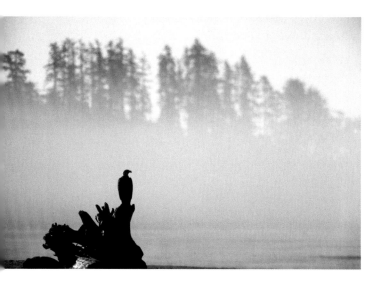

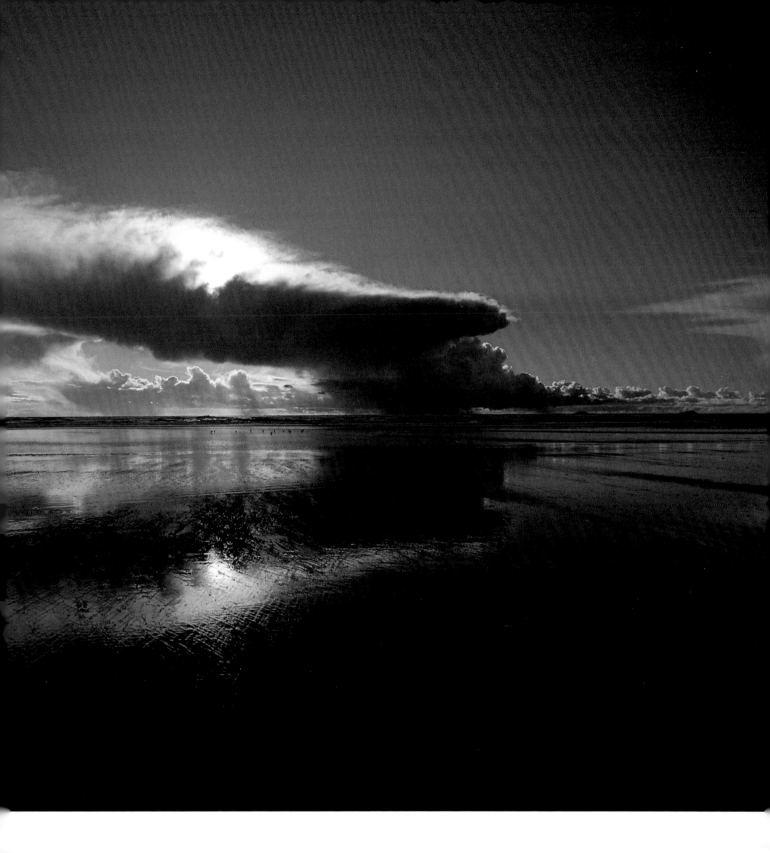

Everything is determined… by forces over which we have no control.
It is determined for the insect as well as for the star. Human beings,
vegetables, or cosmic dust—we all dance to a mysterious tune,
intoned in the distance by an invisible piper.

A L B E R T E I N S T E I N

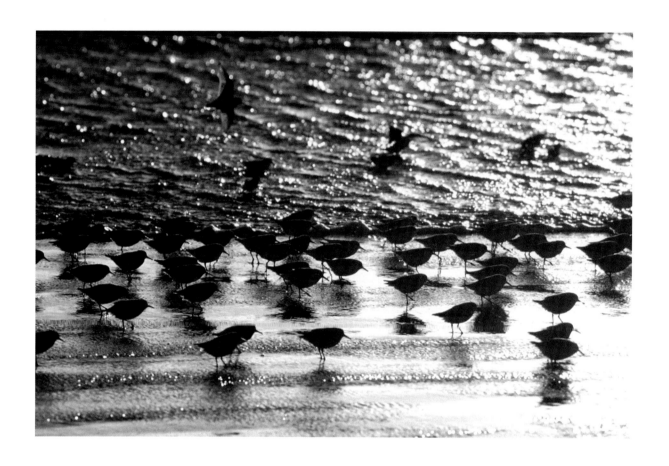

Fame or integrity: which is more important?
Money or happiness: which is more valuable?
Success or failure: which is more destructive?

L A O - T S U

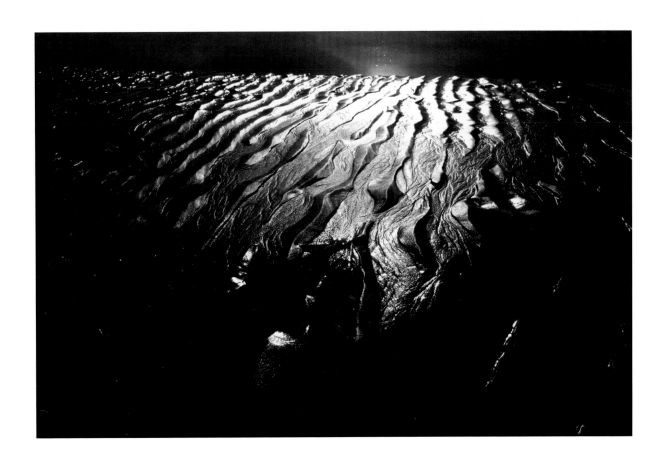

A man is rich in proportion to the number of things
he can afford to let alone.

HENRY DAVID THOREAU

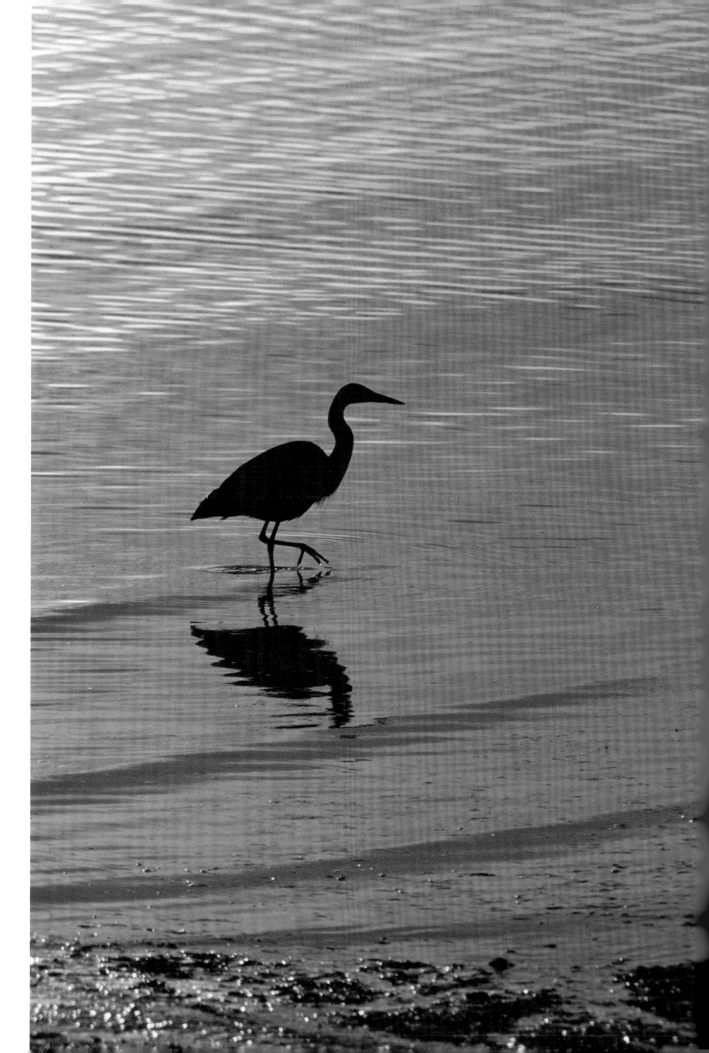

If you look to others for fulfillment,
You will never truly be fulfilled.
If your happiness depends on money,
You will never be happy with yourself.
Be content with what you have;
Rejoice in the way things are.
When you realize there is nothing lacking,
The whole world belongs to you.

LAO-TSU

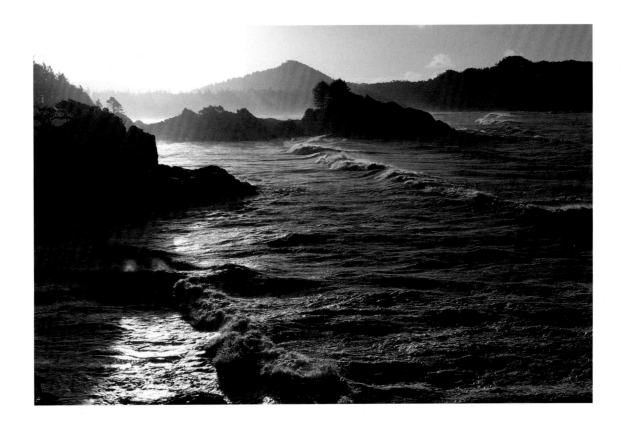

Security is mostly a superstition. It does not exist in nature…
Life is either a daring adventure or nothing…

HELEN KELLER

To see the world in a grain of sand,
And heaven in a wild flower,
Hold infinity in the palm of your hand,
And eternity in an hour.

WILLIAM BLAKE

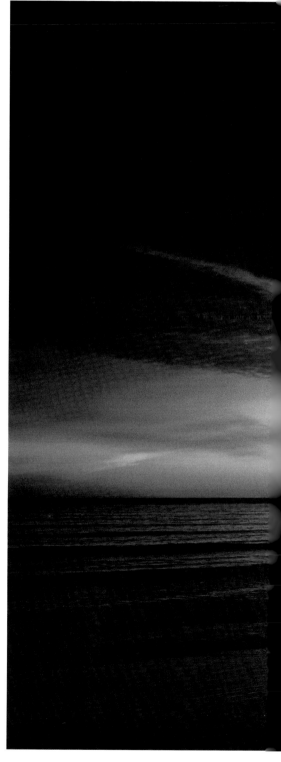

If the doors of perception were cleansed,
everything would appear to man as it is—infinite.

WILLIAM BLAKE

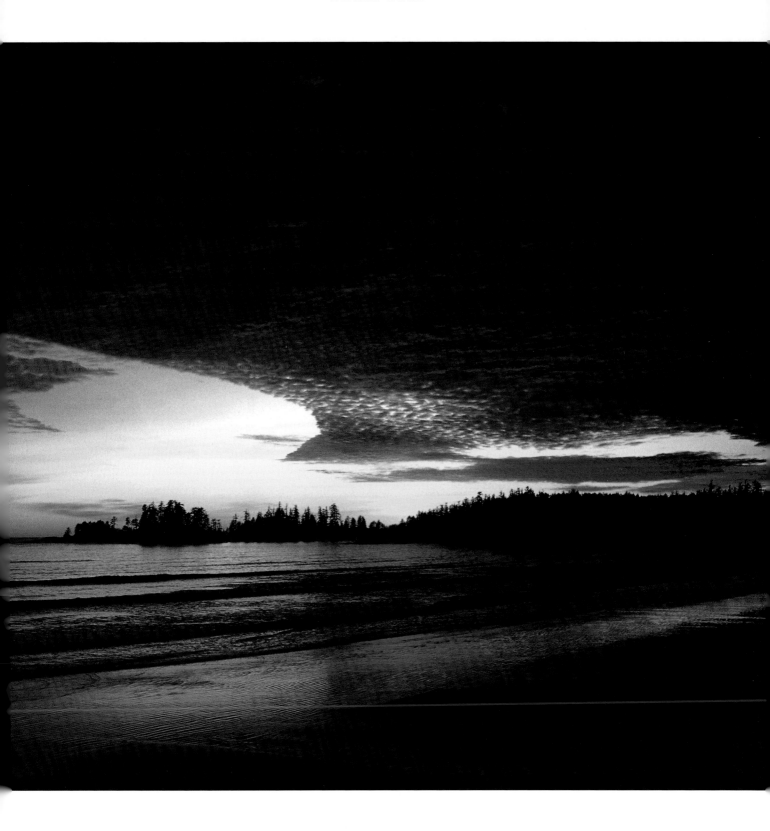

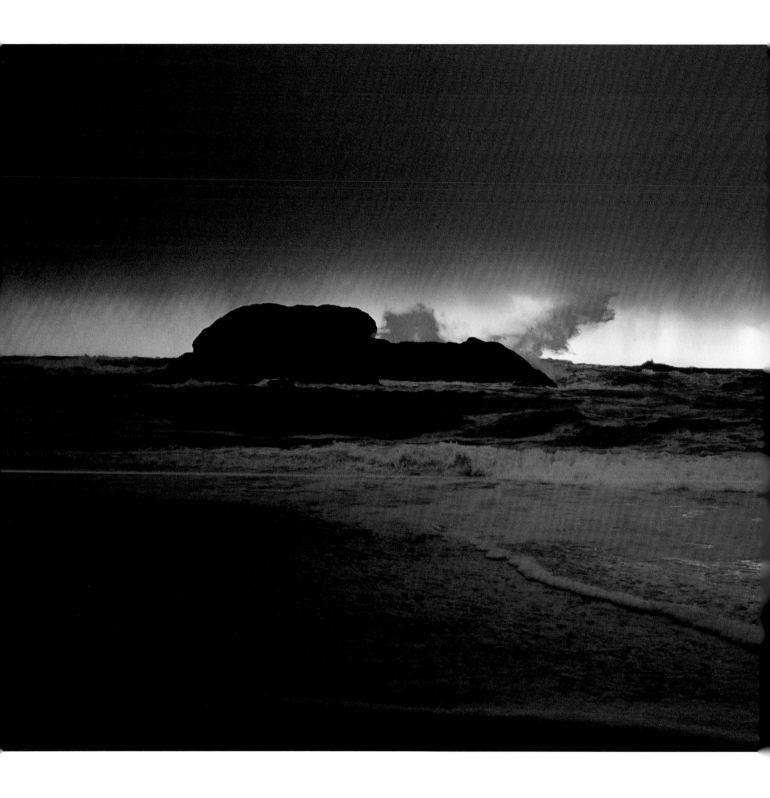

Rejoicing to high heaven, then sad unto death—
this is the fate of those who depend upon an inner accord with
other persons whom they love.

THE I CHING

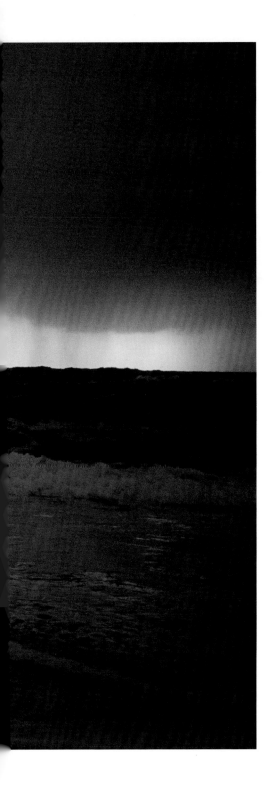

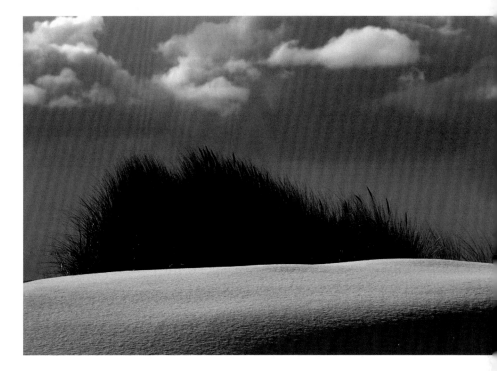

And ever has it been that love knows not its own depth
until the hour of separation.

KAHLIL GIBRAN

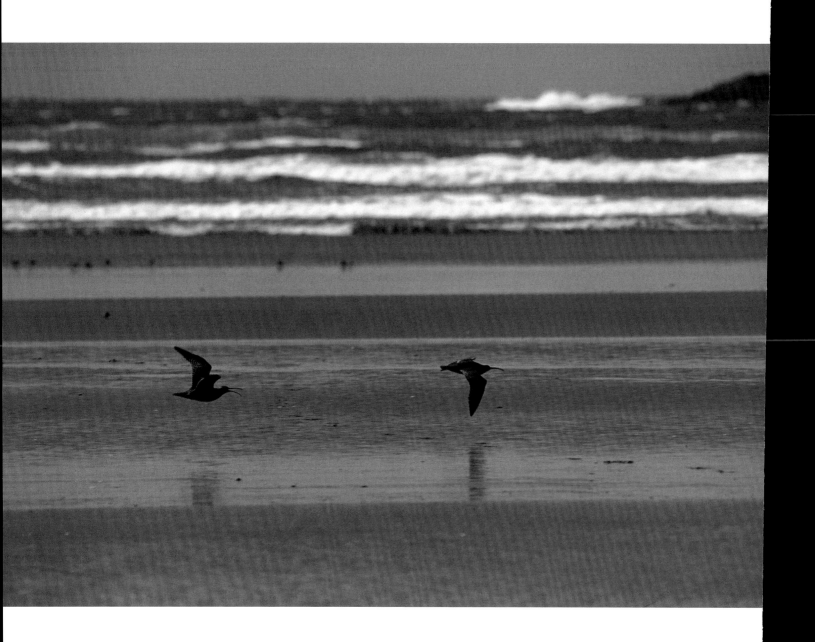

How often attachment is mistaken for love!

SOGYAL RINPOCHE

Love possesses not nor would it be possessed;
For love is sufficient unto love.

Kahlil Gibran

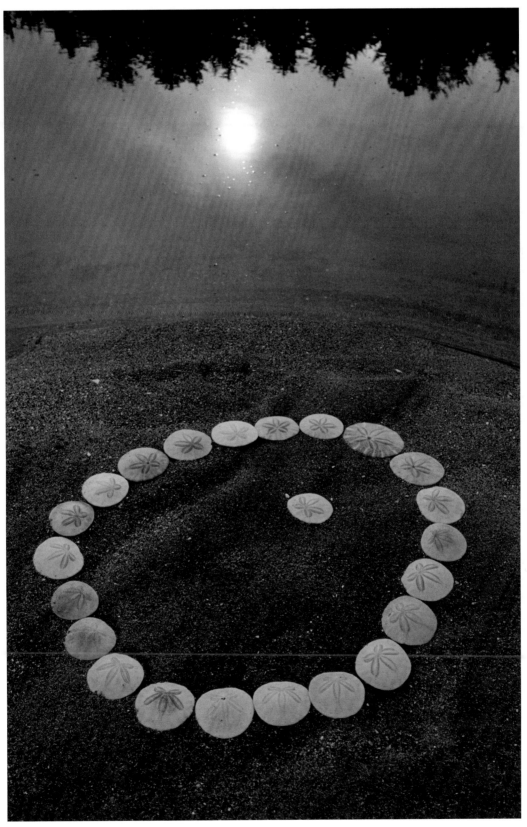

...the selfsame well from which your laughter rises
was oftentimes filled with your tears.
And how else can it be?
The deeper that sorrow carves into your being,
the more joy you can contain.

KAHLIL GIBRAN

Love is like the perfume of a flower; one or the many can smell it.
What matters is the perfume, not to whom it belongs.

J. KRISHNAMURTI

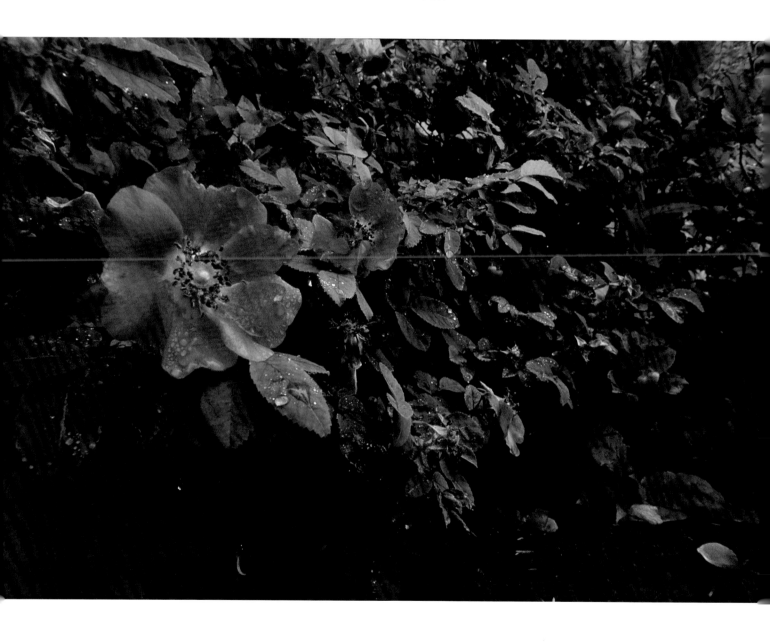

Your task is not to seek for love, but merely to seek and find all the barriers within yourself that you have built against it.

JALAL AD-DIN RUMI

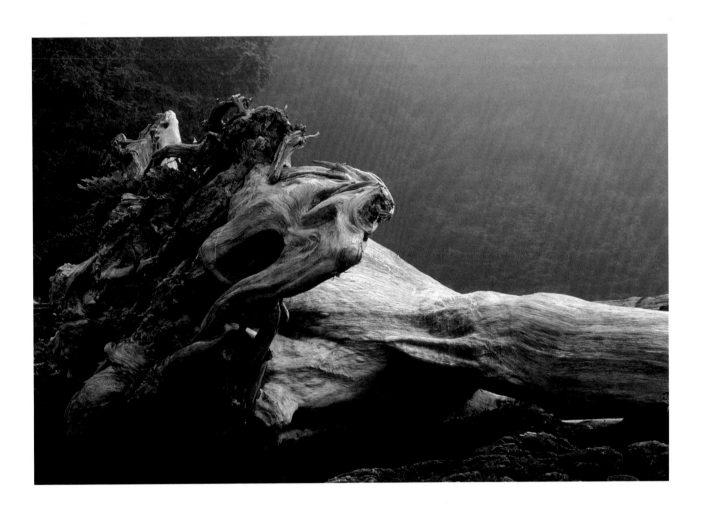

The ultimate lesson all of us have to learn is unconditional love,
which includes not only others but ourselves as well.

ELISABETH KÜBLER-ROSS

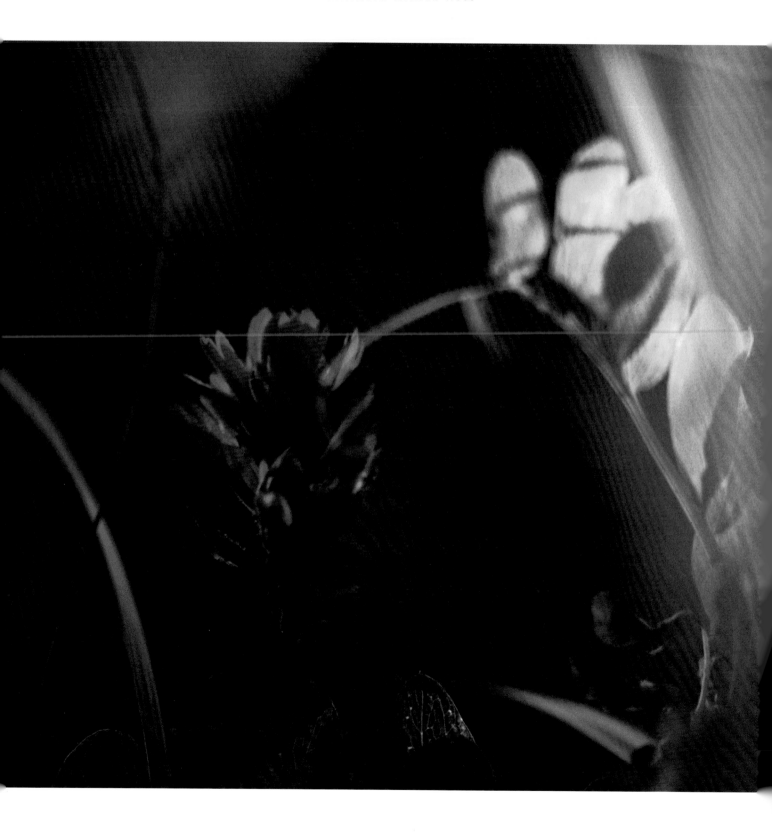

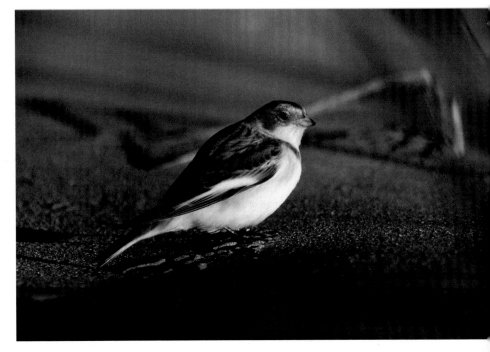

You yourself, as much as anyone in the entire universe,
deserve your love and affection.

BUDDHA

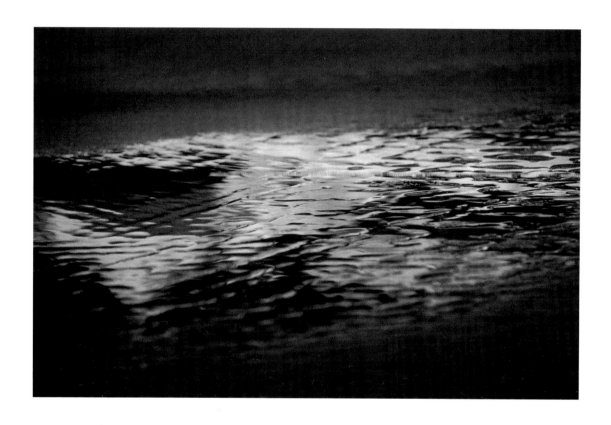

Where shall you seek beauty, and how shall you find
her unless she herself be your way and your guide ?

Kahlil Gibran

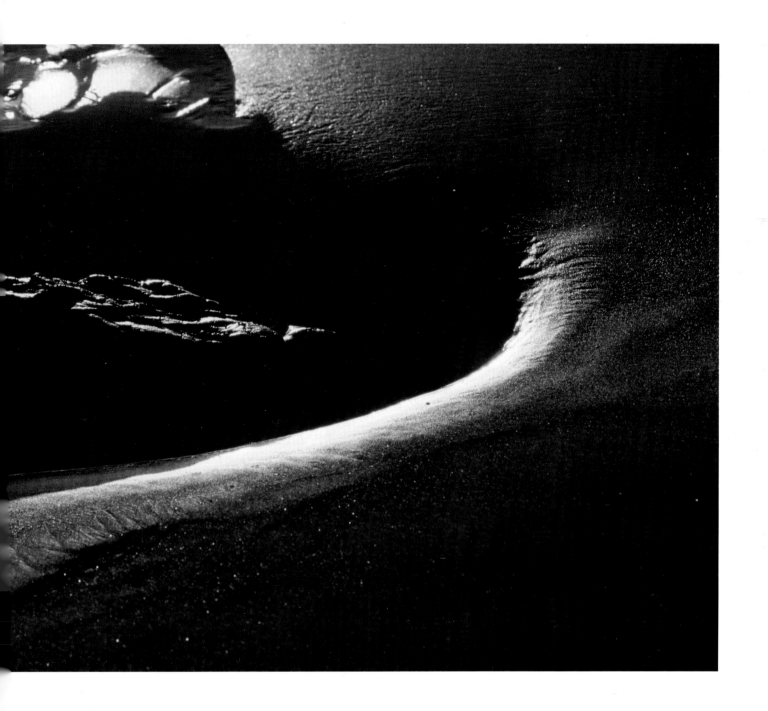

Not in nature but in man is all the beauty and worth he sees.
The world is very empty, and is indebted to this gilding,
exalting soul for all its pride.

RALPH WALDO EMERSON

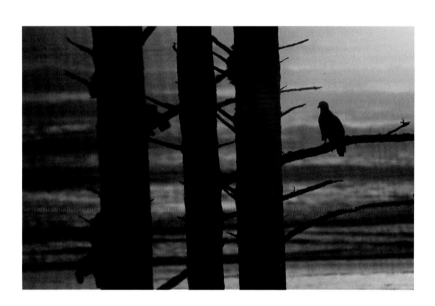

The ideals which have guided my way, and time after
time have given me the energy to face life, have been
Kindness, Beauty and Truth.

ALBERT EINSTEIN

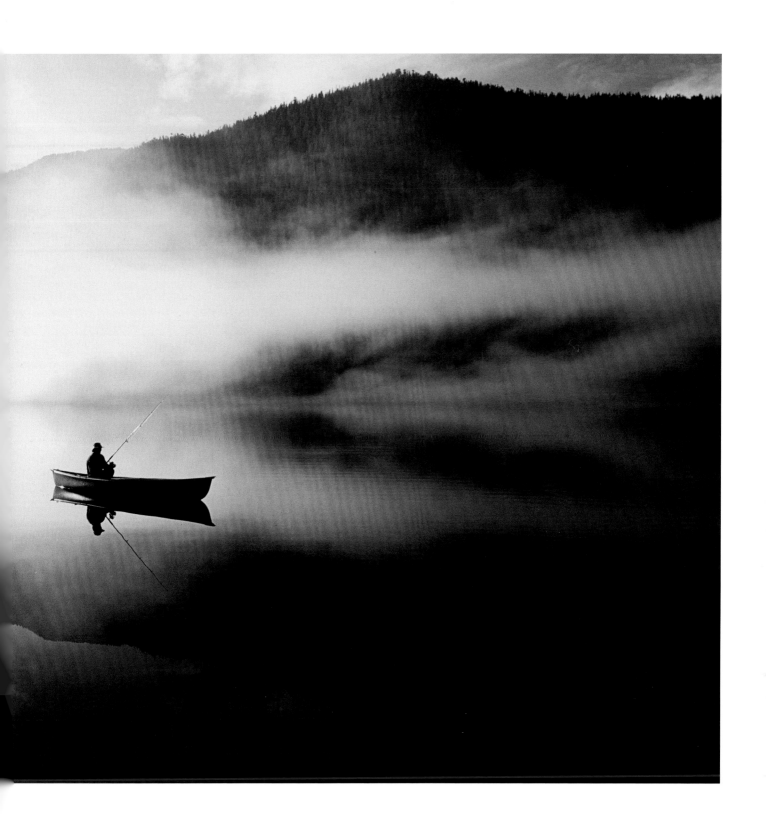

The best and most beautiful things in the world cannot be seen
nor even touched, but just felt in the heart.

HELEN KELLER

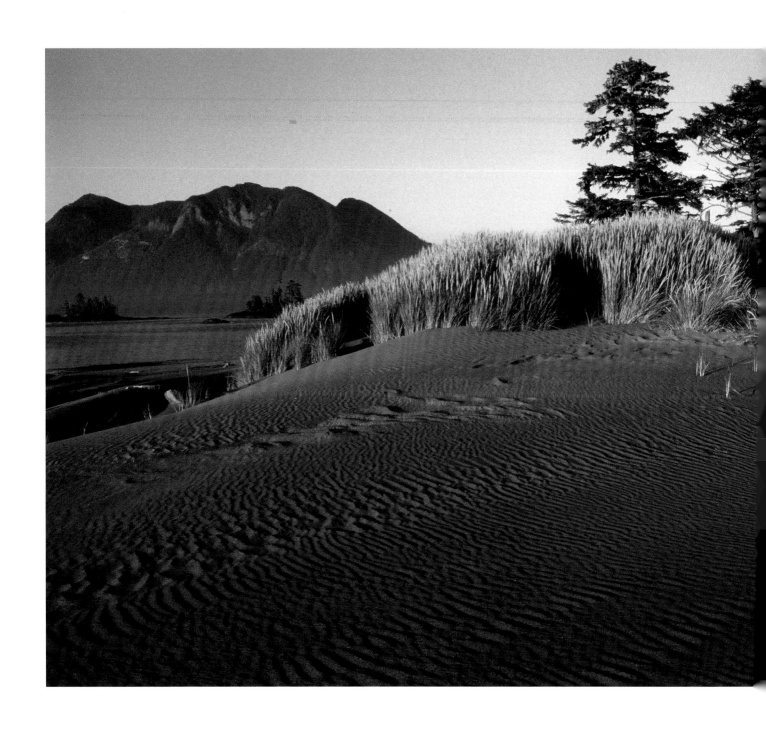

It is a ... necessary thing for us to turn again to the earth
and in the contemplation of her beauties to know of
wonder and humility.

RACHEL CARSON

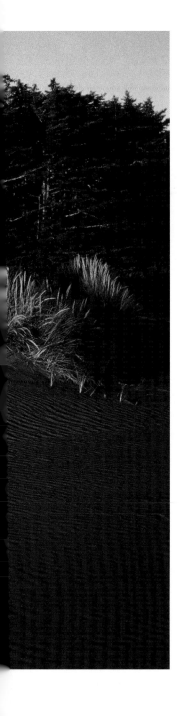

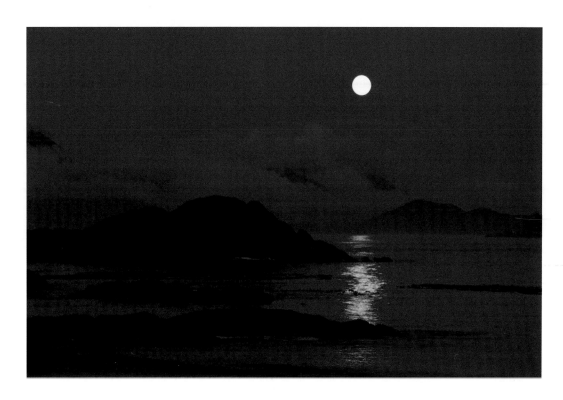

The man who has seen the rising moon break out of the clouds at midnight, has been present like an archangel at the creation of light and of the world.

RALPH WALDO EMERSON

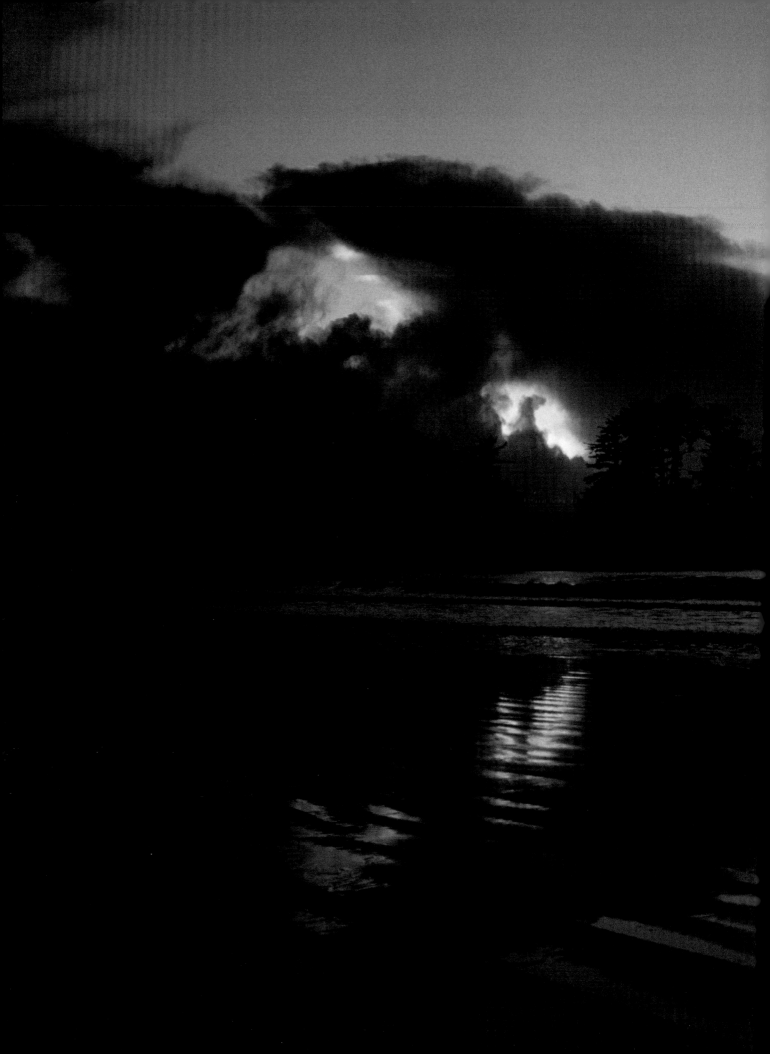

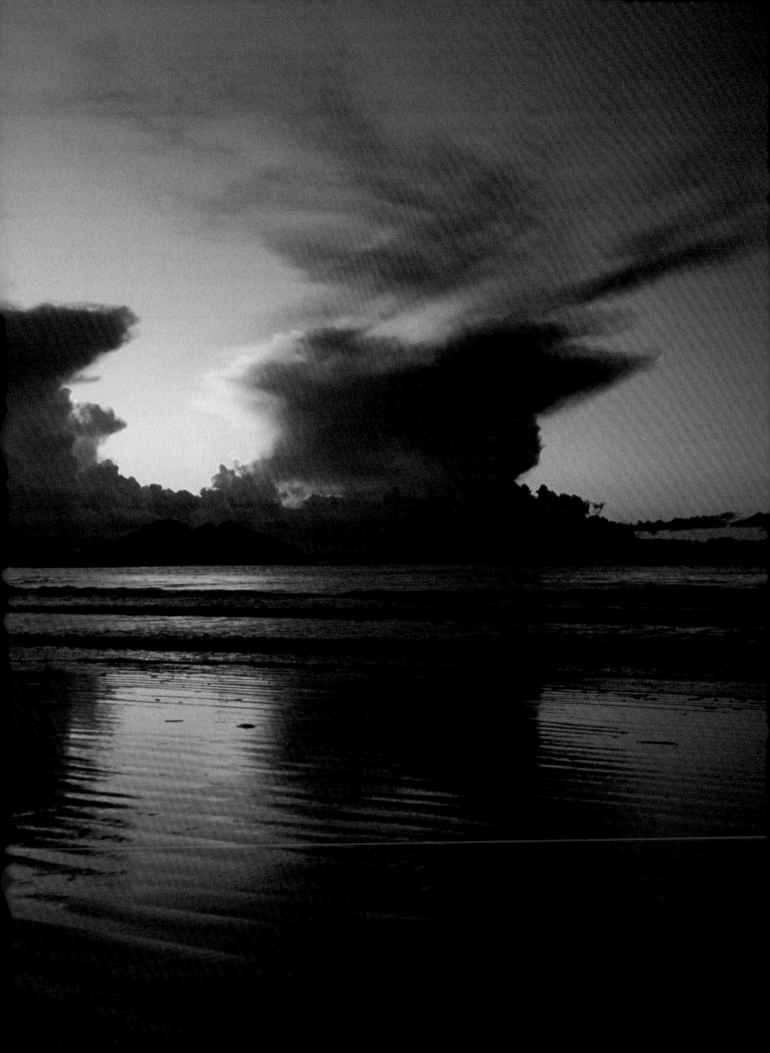

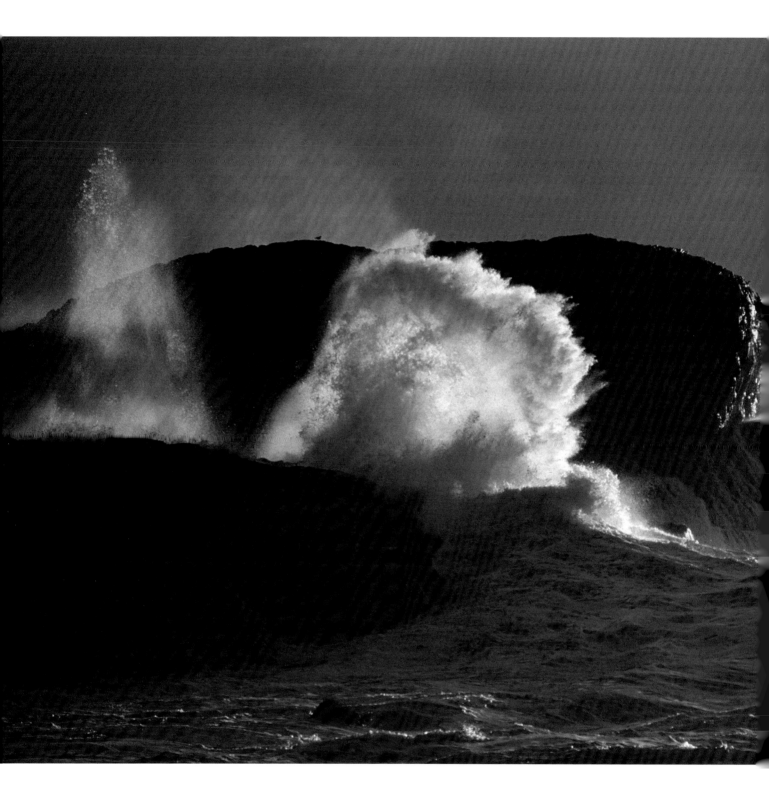

Everything that arises, does its dance and dies.

BUDDHIST SAYING

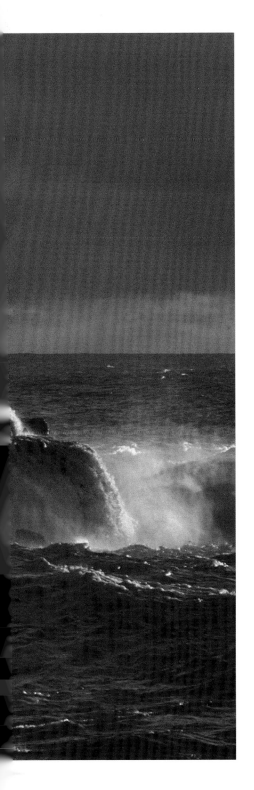

... what is it to die but to stand naked in the wind
and to melt into the sun?
And what is it to cease breathing, but to free the breath
from its restless tides,
that it may rise and expand and seek god unencumbered?

KAHLIL GIBRAN

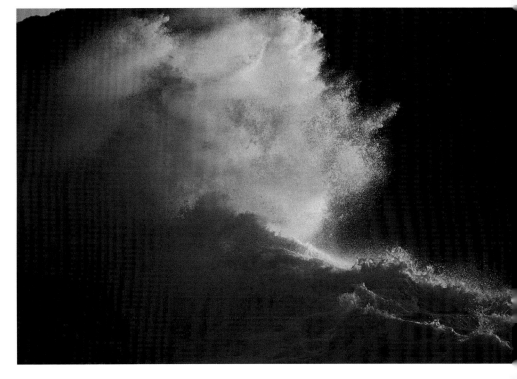

… let children walk with Nature, let them see the beautiful blendings and communions of death and life, their joyous inseparable unity … and they will learn that death is stingless indeed, and as beautiful as life, and that the grave has no victory, for it never fights. All is divine harmony.

JOHN MUIR

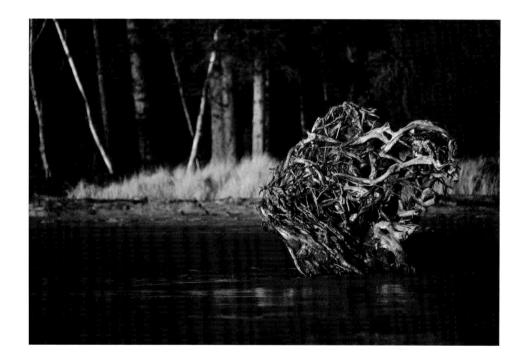

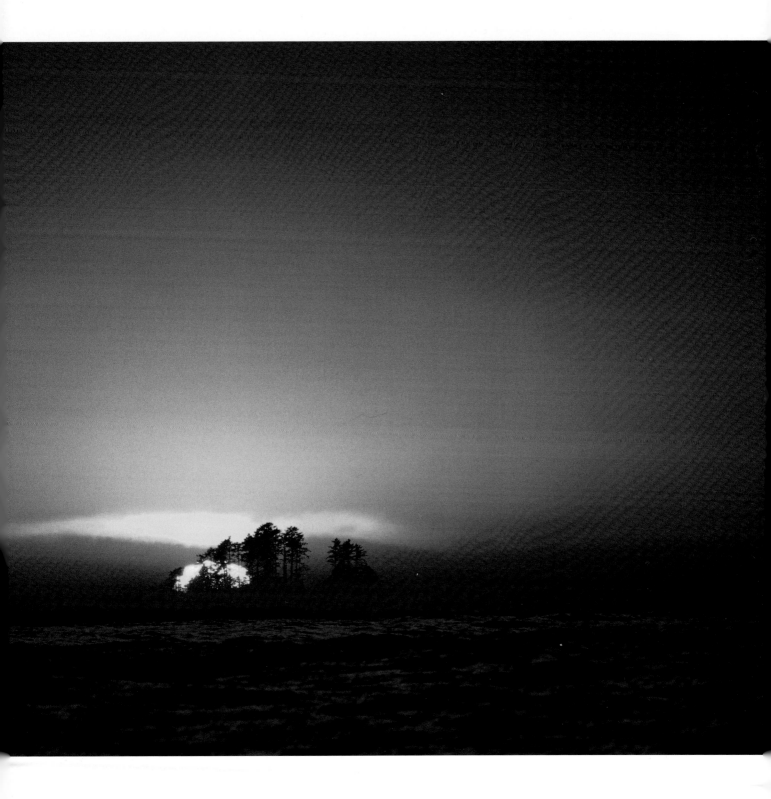

Love is the supreme elixir that overcomes
the sovereignty of death.

SHANTIDEVA

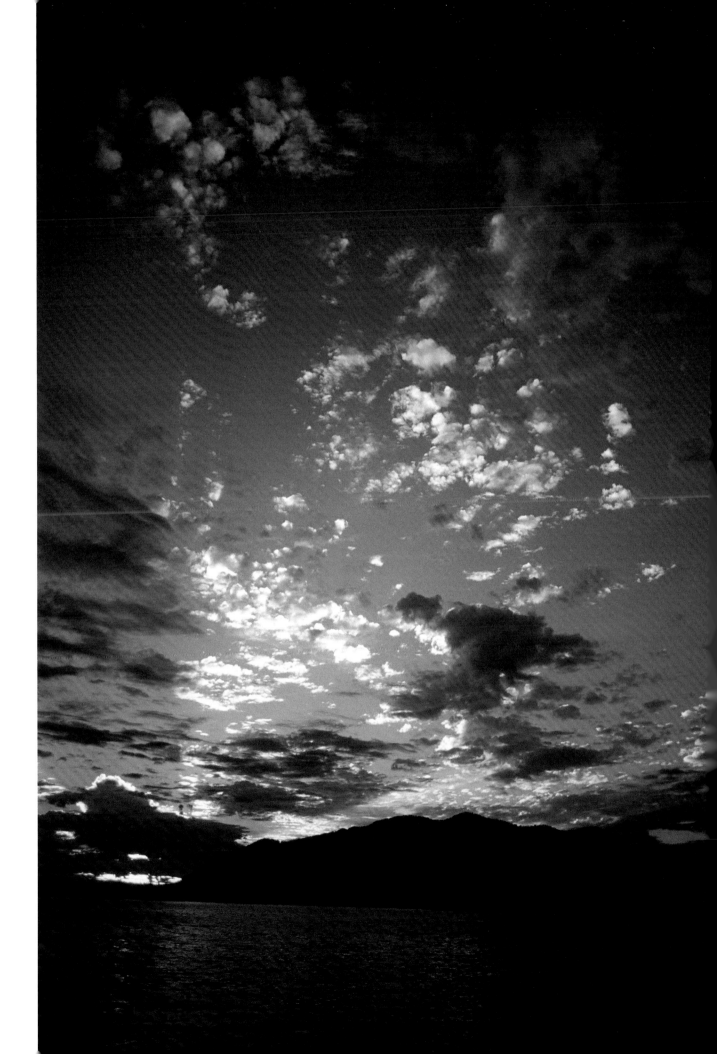

The master gives himself up to whatever the moment brings.
He knows that he is going to die, and has nothing left to hold
on to: no illusions in his mind, no resistances in his body.
He doesn't think about his actions; they flow from the core of
his being. He holds nothing back from life; therefore he is ready
for death, as a man is ready for sleep after a good day's work.

Lao-tsu

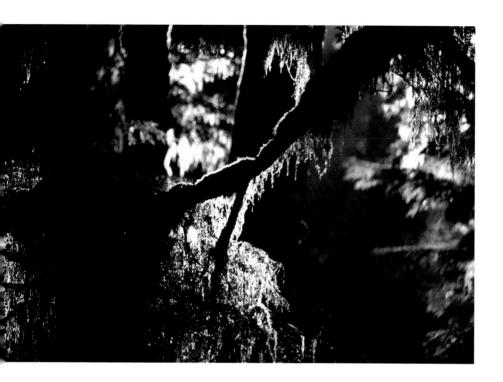

Talk of immortality! After a whole day in the woods,
we are already immortal. When is the end of such a day?

JOHN MUIR

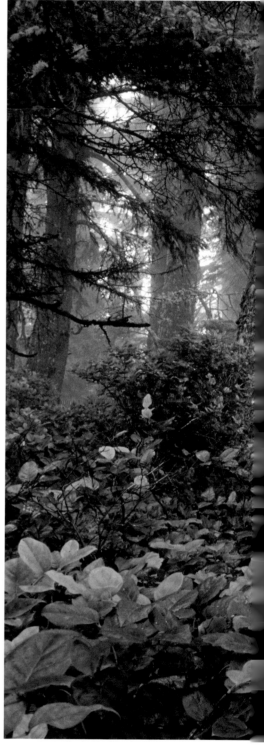

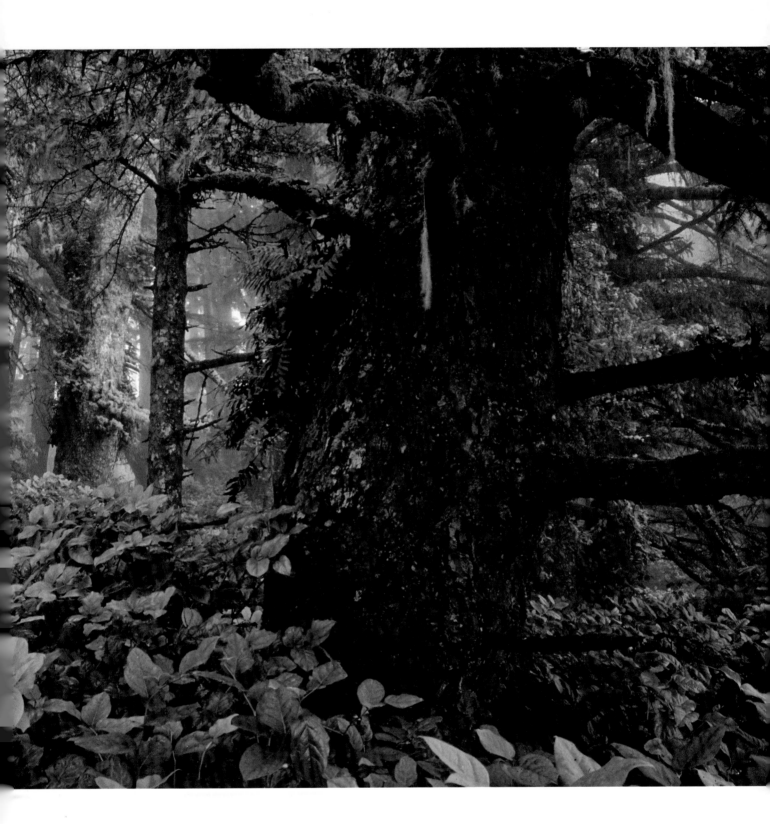

The most beautiful thing we can experience is the mysterious. It is the fundamental emotion which stands at the cradle of true art and true science. He who does not know it and can no longer wonder, no longer feel amazement, is as good as dead, a snuffed-out candle.

ALBERT EINSTEIN

Keep close to Nature's heart … and break clear away,
once in a while, and climb a mountain or spend a week in
the woods. Wash your spirit clean.

JOHN MUIR

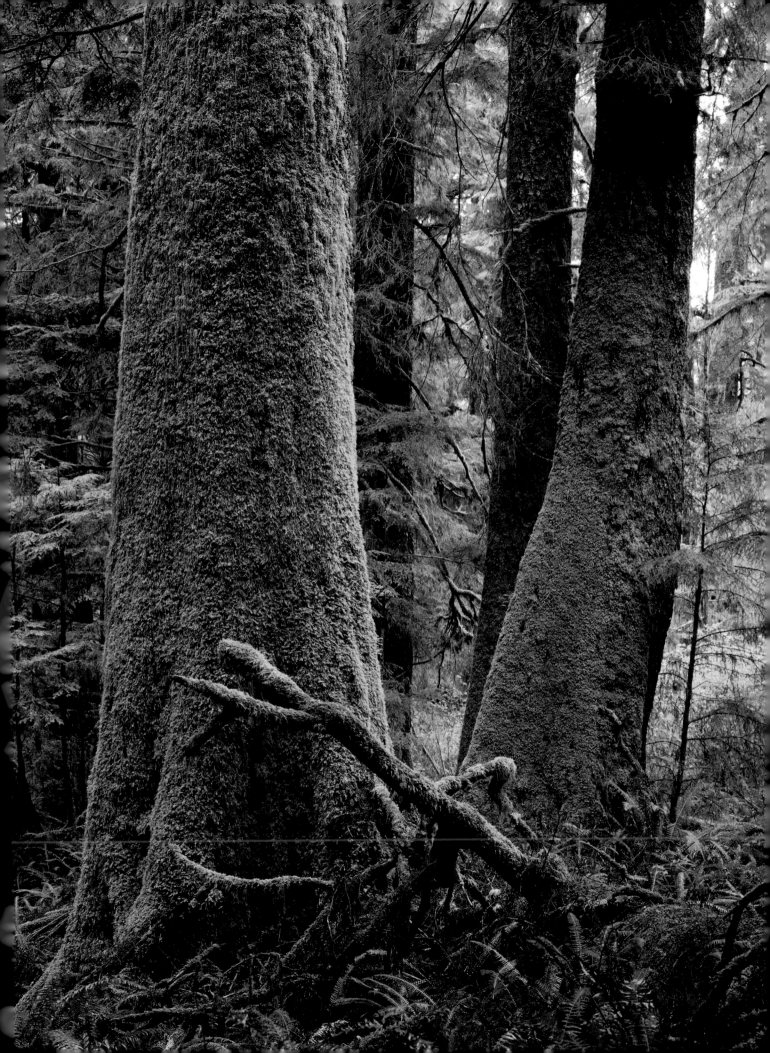

… if a single man plant himself indomitably on
his instincts, and there abide, the huge world will
come round to him …

R ALPH W ALDO E MERSON

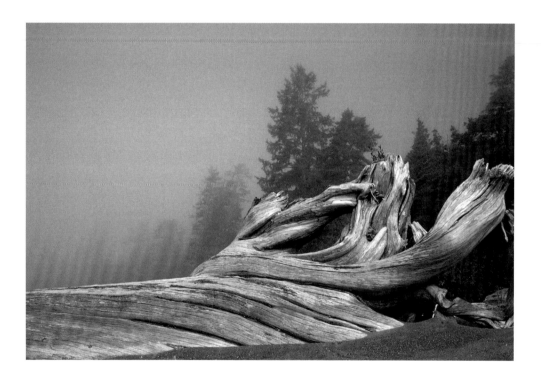

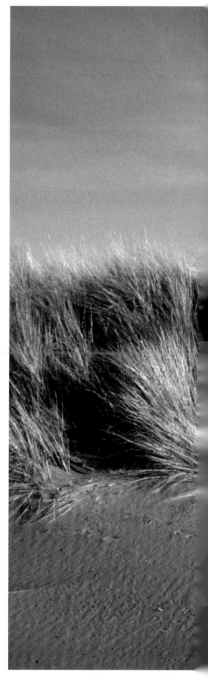

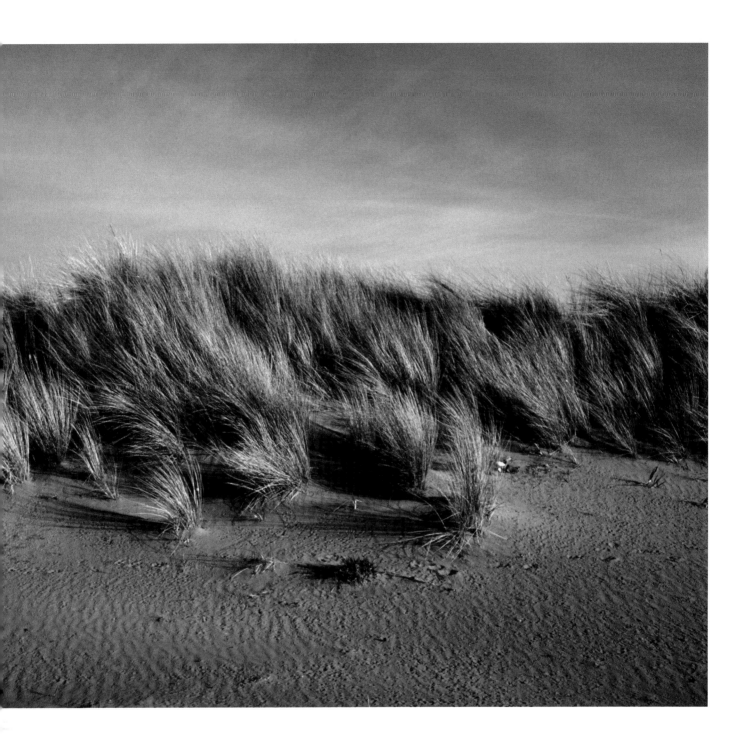

When a man is really whole, all things will come to him.

THE I CHING

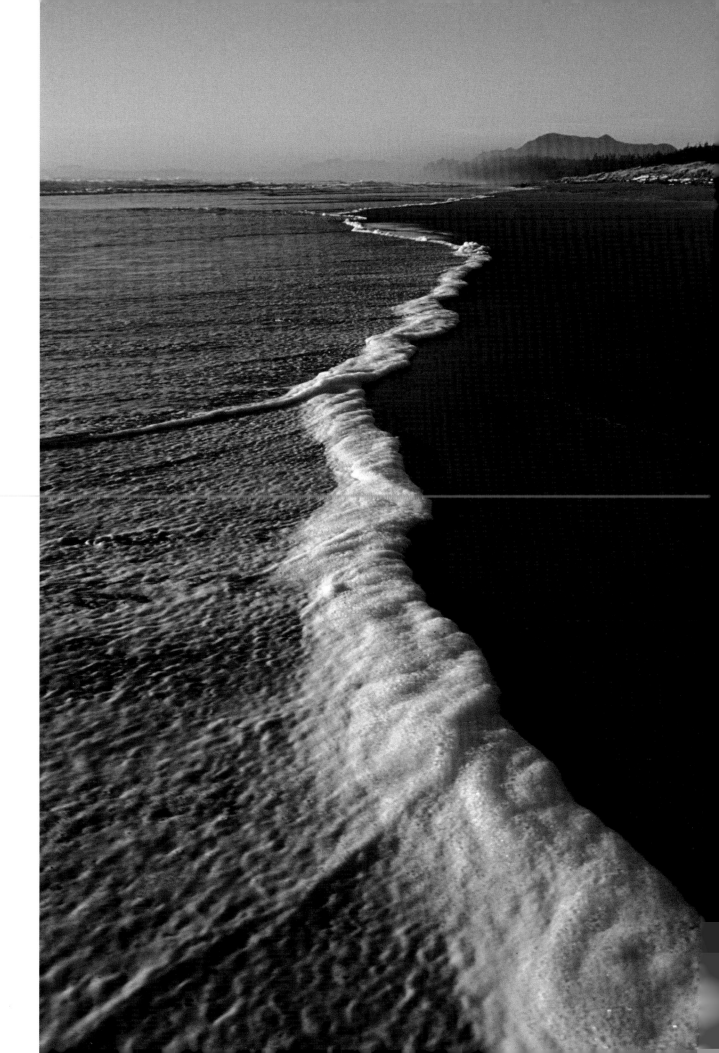

There is a pleasure in the pathless woods,
There is a rapture on the lonely shore,
There is society, where none intrudes,
By the deep Sea, and music in its roar:
I love not man the less, but Nature more,
From these our interviews, in which I steal
From all I may be, or have been before,
To mingle with the Universe, and feel
What I can ne'er express, yet cannot all conceal.

GEORGE GORDON BYRON

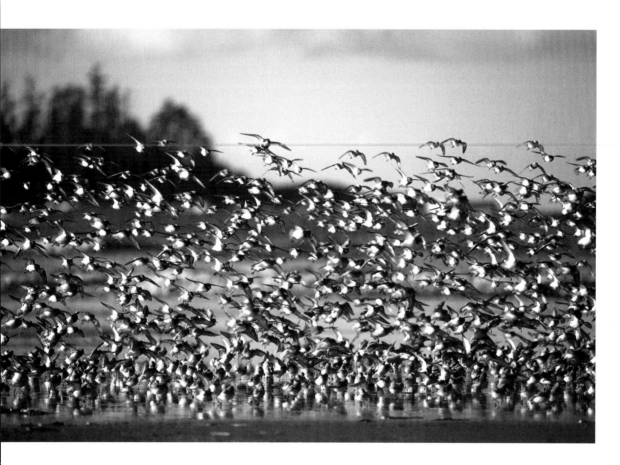

Out of clutter find simplicity. From discord, find harmony.
In the middle of difficulty, lies opportunity.

ALBERT EINSTEIN

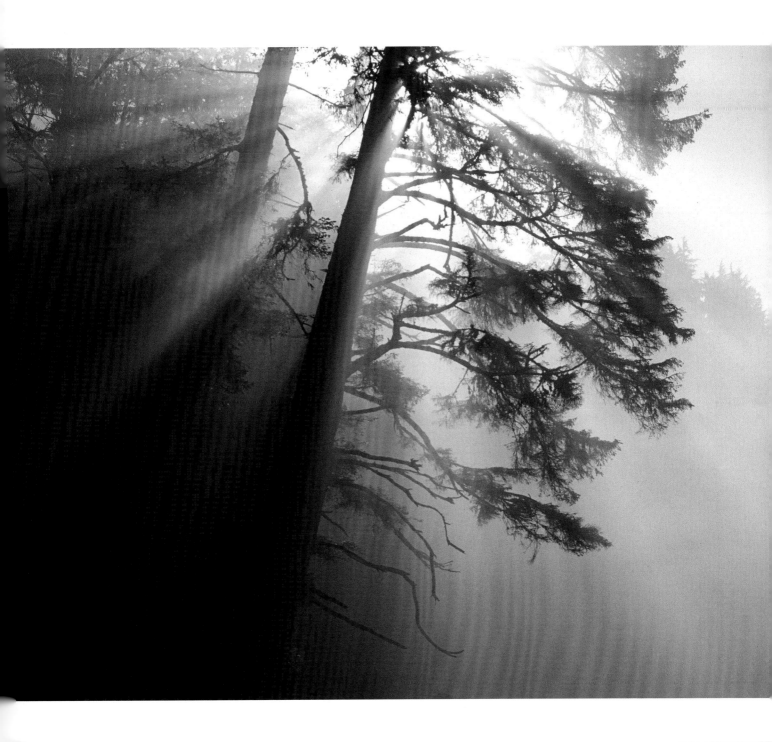

Do not attack the dark principle directly. The Dark will
dissipate with the coming of the light.

THE I CHING

Why try to solve a problem? *Dissolve it!* Bathe it
in a saline solution of neglect, contempt, and indifference.

HENRY MILLER

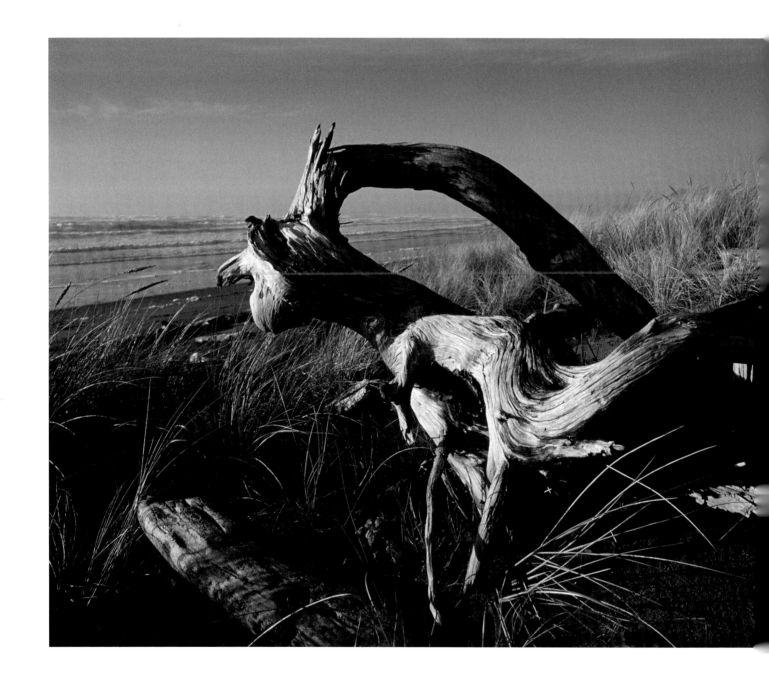

The angel in man is ready to emerge whenever that dread
human will to have it one's own way is kept in abeyance.

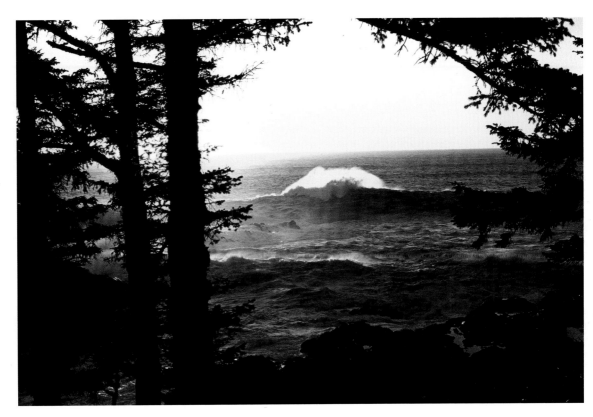

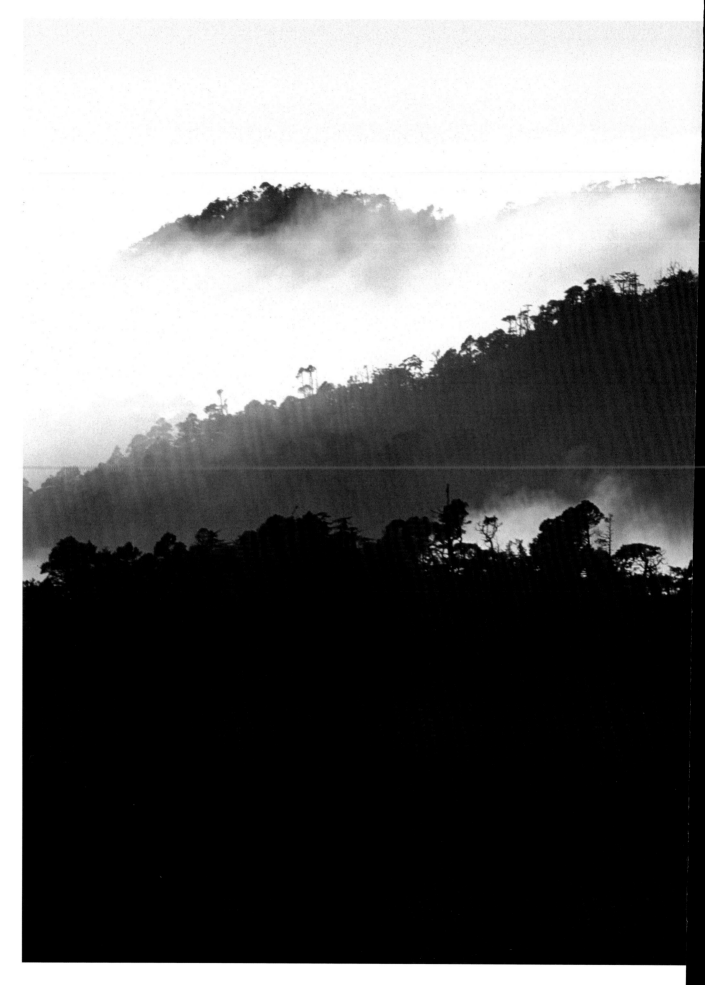

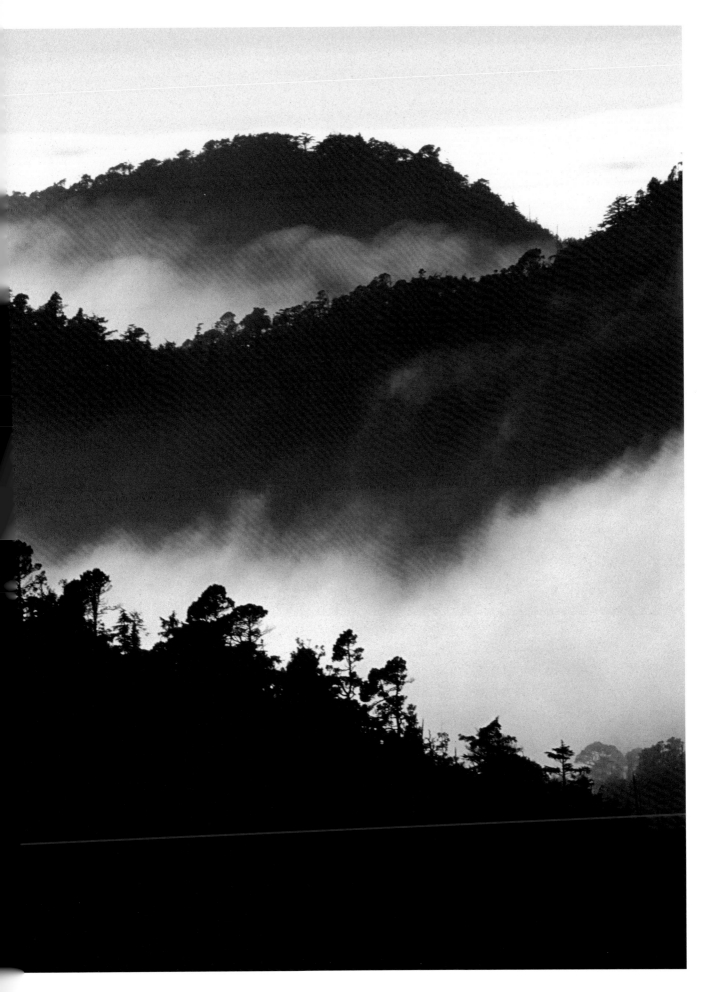

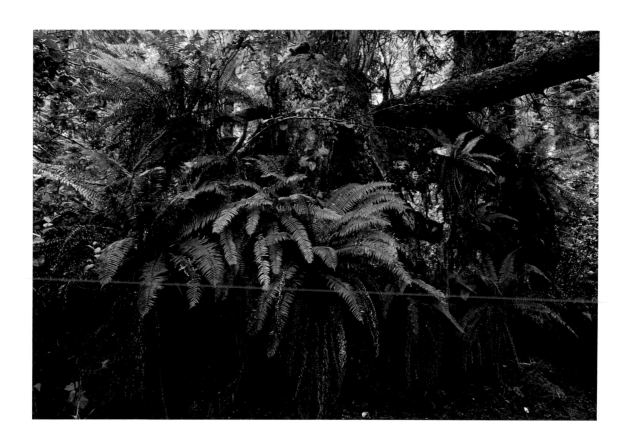

Planning for the future is like going fishing in a dry gulch;
Nothing ever works out as you wanted, so give up all your schemes
and ambitions. If you have got to think about something—
make it the uncertainty of the hour of your death.

GYALSE RINPOCHE

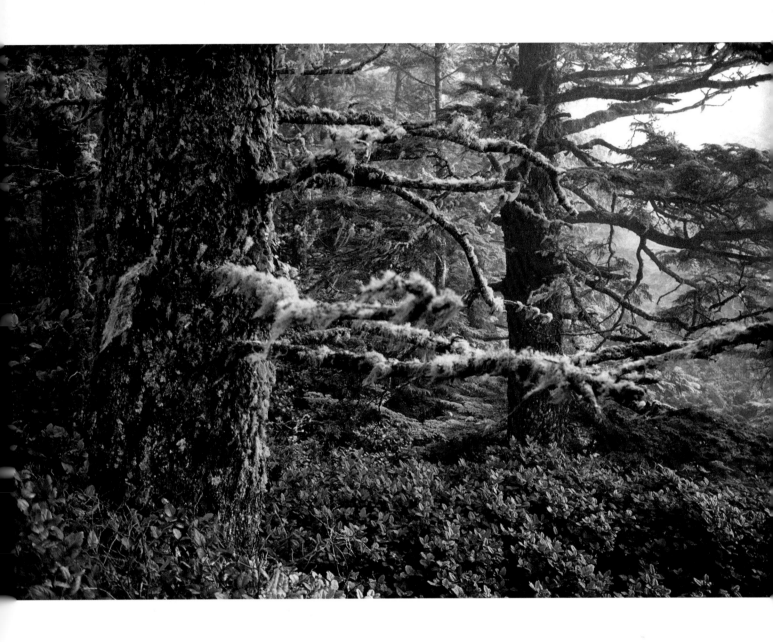

I never think of the future, it comes soon enough.

ALBERT EINSTEIN

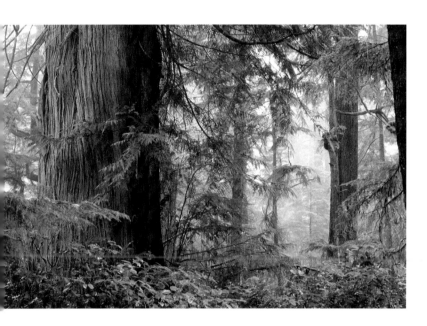

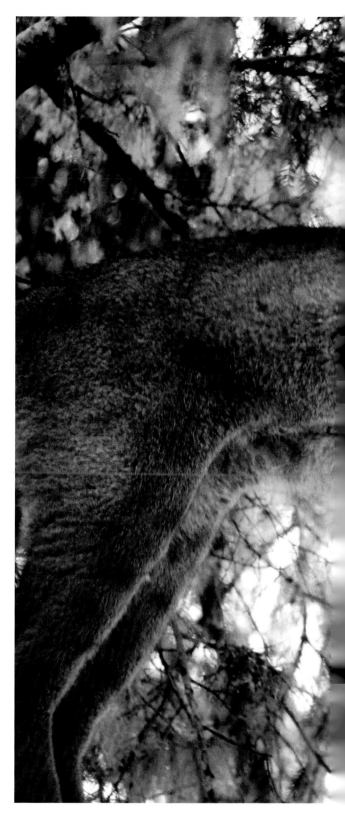

Trees are sanctuaries. Whoever knows how to speak to them,
whoever knows how to listen to them, can learn the truth.
They do not preach learning and precepts,
they preach undeterred by particulars, the ancient laws of life.

HERMANN HESSE

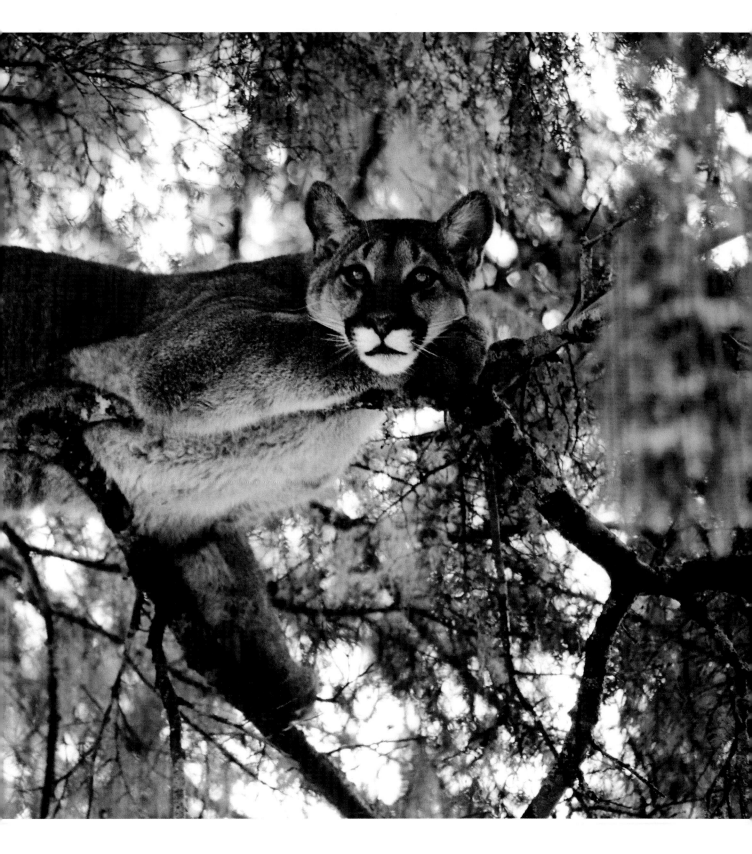

Nothing in life is to be feared. It is only to be understood.

MARIE CURIE

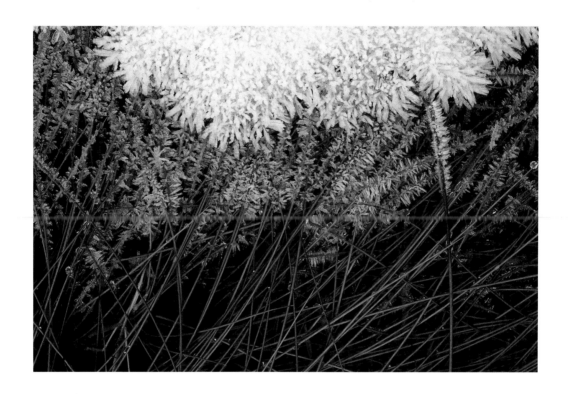

That which today calls itself science gives us more and more information,
an indigestible glut of information, and less and less understanding.

EDWARD ABBEY

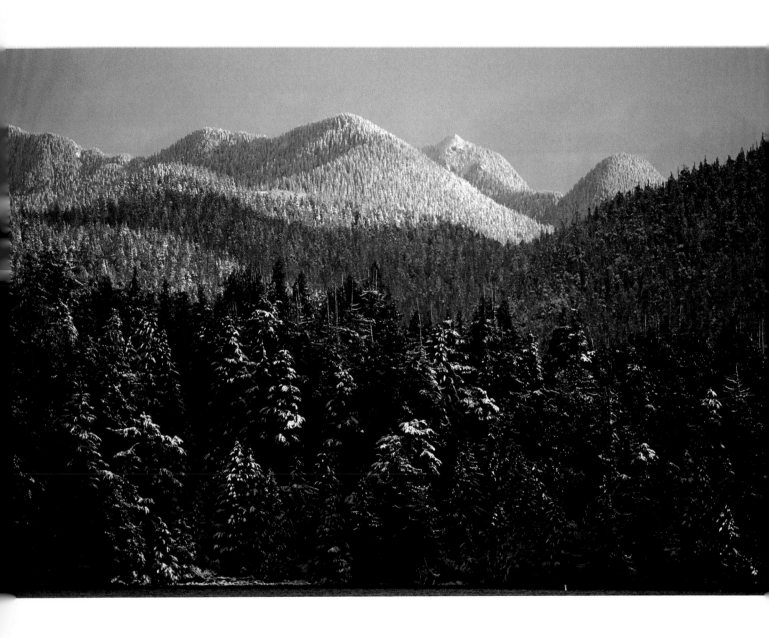

Those who understand only what can be explained understand very little.

MARIE VON EBNER-ESCHENBACH

Man has received from Heaven a nature innately good to guide him
in all his movements. By devotion to this divine spirit within himself
he attains an unsullled Innocence that leads him to do right
with instinctive sureness and without ulterior thought of reward
or personal advantage.

THE I CHING

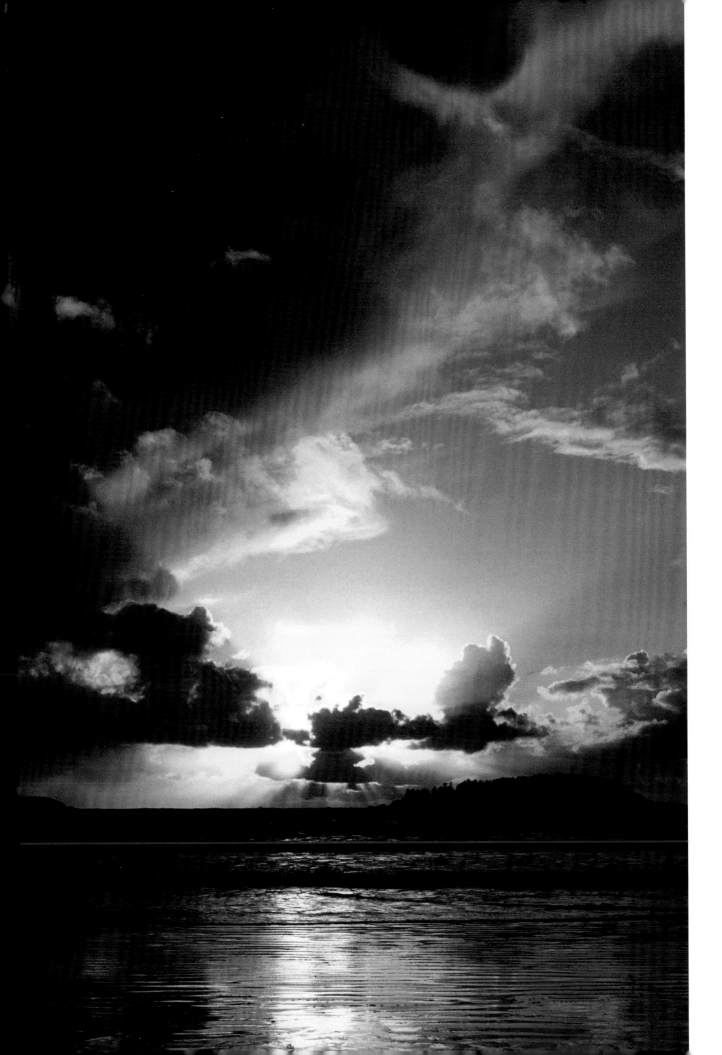

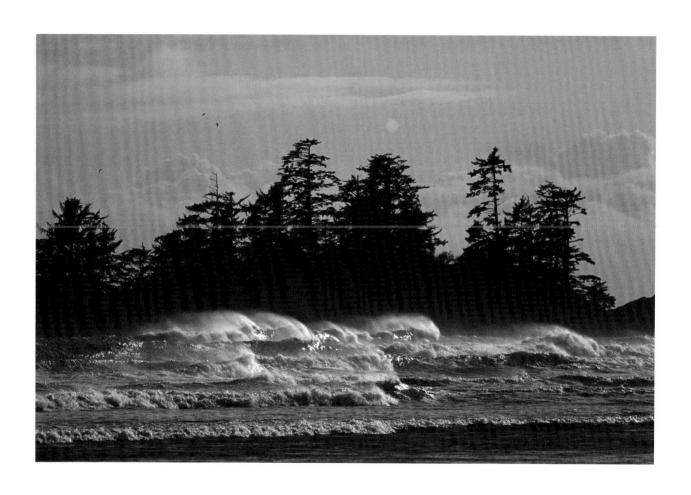

Men imagine that they communicate their virtue or vice only by overt actions,
and do not see that virtue or vice emit a breath every moment.

RALPH WALDO EMERSON

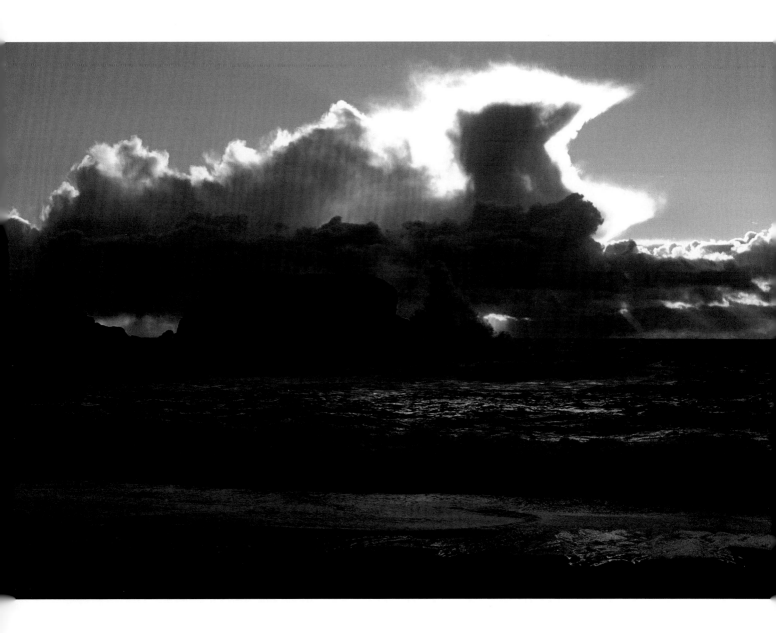

A man passes for what he is worth. What he is engraves itself on his face,
on his form, on his fortunes, in letters of light, which all men may read but himself.

RALPH WALDO EMERSON

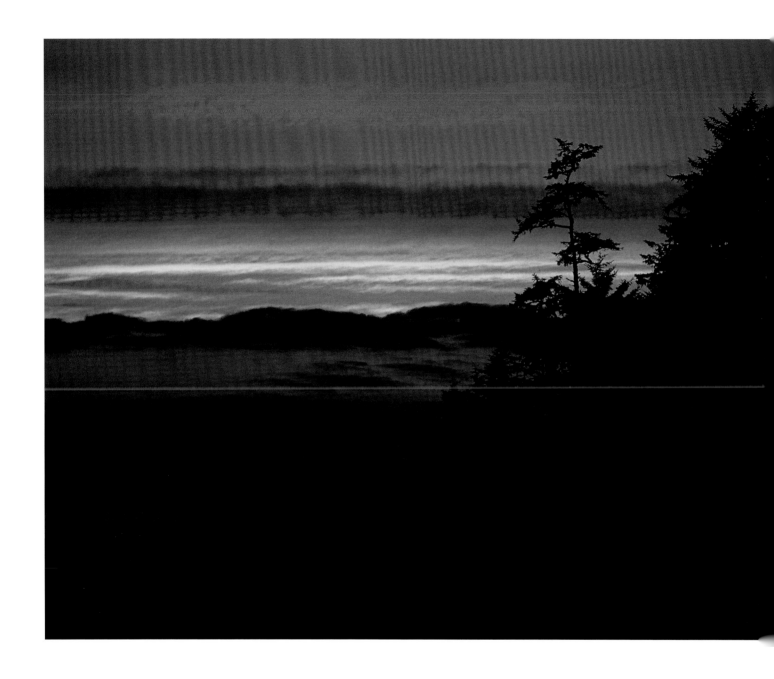

Don't talk to me about other worlds, separate realities, lost continents,
or invisible realms—I know where I belong. Heaven is home.
Utopia is here. Nirvana is now.

EDWARD ABBEY

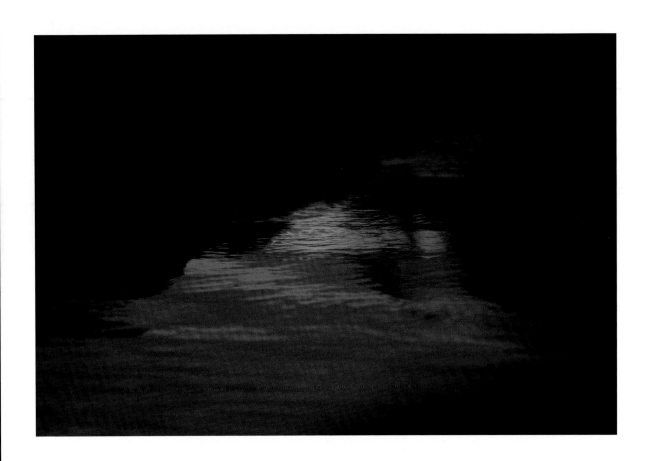

I have no money, no resources, no hopes.
I am the happiest man alive.

HENRY MILLER

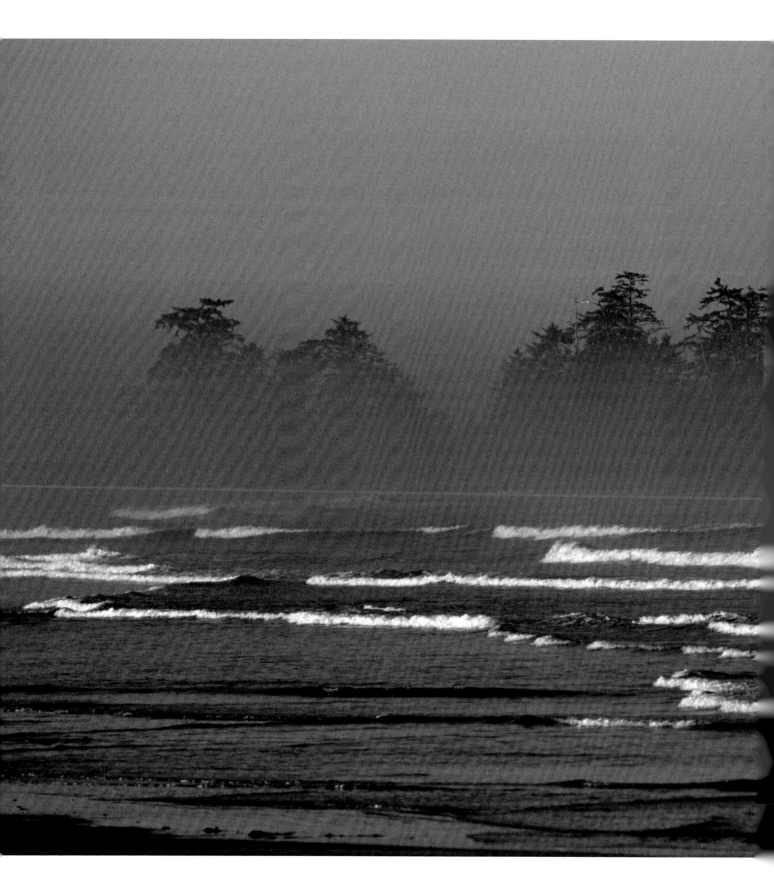

Children don't heed the life experiences of their parents,
and nations ignore history. Bad lessons always have to be learned anew.

Albert Einstein

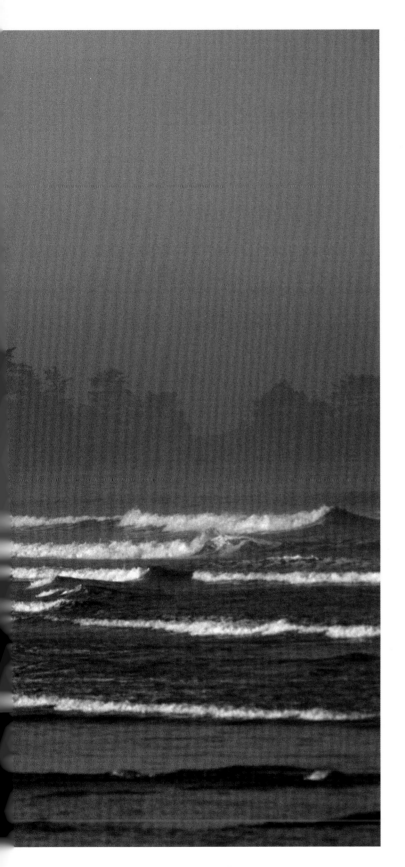

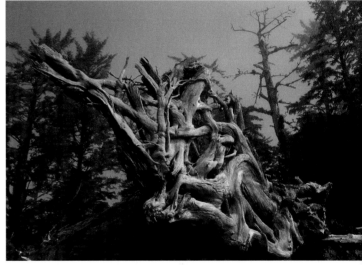

…there is properly no history; only Biography.
Every soul must know the whole lesson for itself—
must go over the whole ground. What it does not see,
what it does not live, it will not know.

RALPH WALDO EMERSON

When you walk to the edge of all the light you have
and take that first step into the darkness of the unknown,
you must believe that one of two things will happen:

There will be something solid for you to stand upon,
or, you will be taught to fly

<div align="right">PATRICK OVERTON</div>

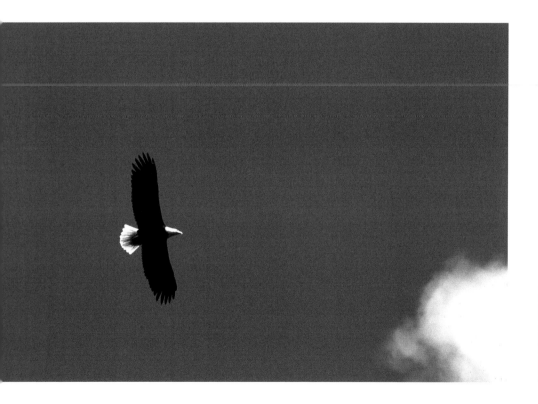

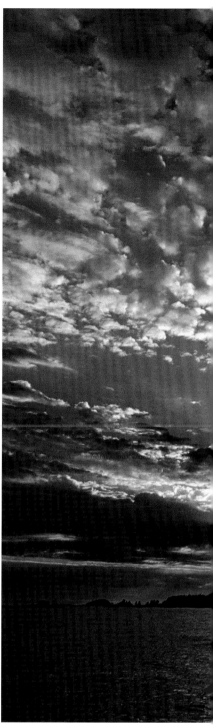

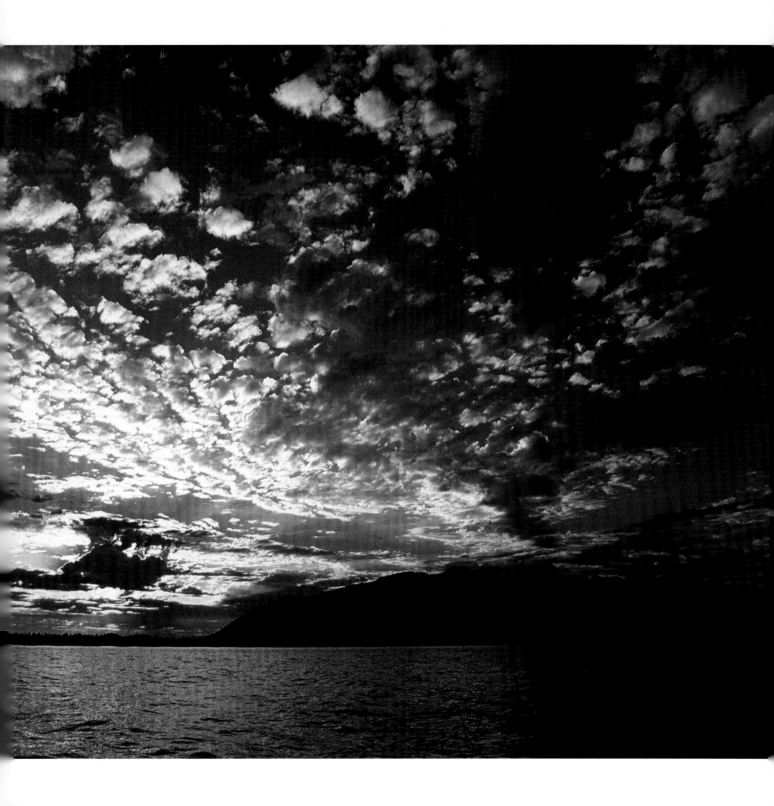

That anything exists at all is…such a mystery, such
a miracle;
I sometimes marvel that anyone can keep a straight
face!

JAN JANZEN

Close your eyes and you will see clearly.
Cease to listen and you will hear Truth.
Be silent and your heart will sing.
Seek no contacts and you will find union.
Be still and you will move forward.
Be gentle and you will need no strength.
Be patient and you will achieve all things.
Be humble and you will remain complete.

TAOIST MEDITATION

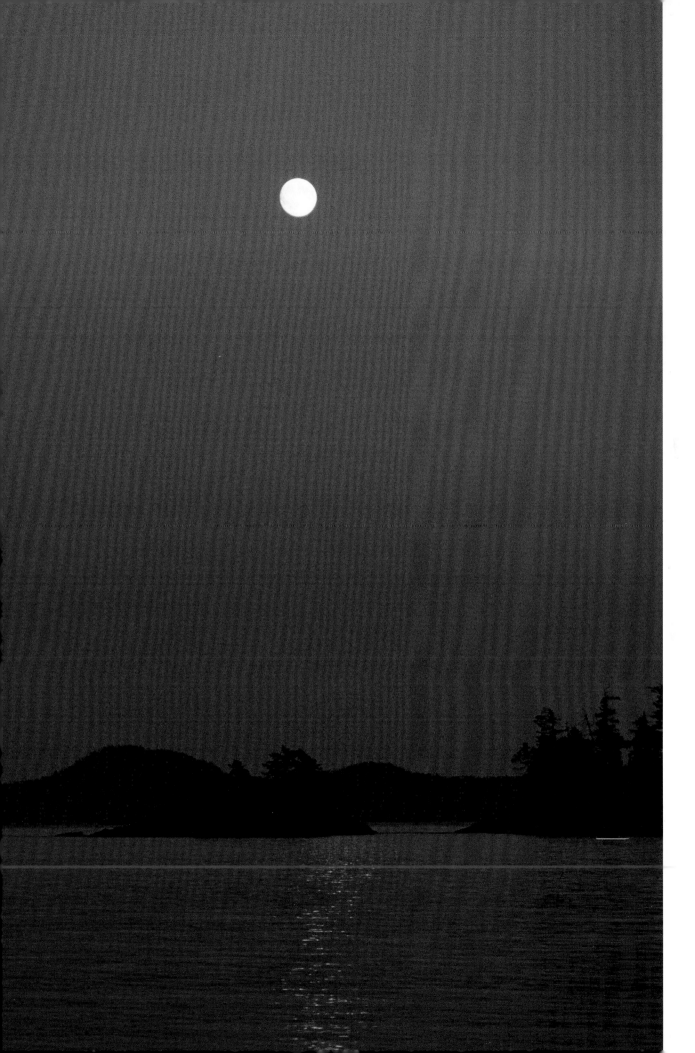

Photograph Captions:

Front dust jacket: View of Clayoquot Sound and Meares Island from Stubbs Island
Back dust jacket: Juvenile long-billed curlews
p.1: Sandhill Creek
pp.2–3: Morning mist, Sombrio
pp.7: Sandhill Creek where it flows past Long Beach
p.8: Long Beach in winter
p.9: Sprig of dune grass, Long Beach
p.10: Bald eagle in Sitka spruce beside Sandhill Creek
p.11: Trumpeter swans on Sandhill Creek
p.12: Dune grass, Long Beach
p.13: Sea star amongst kelp
p.14: Waves, Long Beach
p.15: Mussel shell and sand dollar, Vargas Island
p.16: Indian paintbrush in tidal meadow
pp.18–19: Winter wave at Cox Bay, Tofino
p.20: View of Clayoquot Sound and Meares Island from Stubbs Island
p.21: Cockle shell
p.22: Root of drift log, mouth of Sandhill Creek
p.23: Chesterman Beach, Frank Island
p.24: Flower Rock, off Vargas Island
p. 27: Falls and moss at Ellerslie
p.28: Semipalmated Plover, Stubbs Island
p.29: Early morning fog, medallion beach, Vargas Island
p.30, 31: Sunset, Chesterman Beach
p.32–33: Winter storm, south end of Long Beach
p.34, 35: Reflections in Sandhill Creek
p.36, 37: Winter storm, South Beach, Pacific Rim National Park
p.38: Juvenile long-billed curlews
p.39: Red clouds at sunset, Chesterman Beach
p.40: Breaking wave, Medallion Beach
p.41: View from south end of Vargas Island
p.42: Pool of cedar-stained water above the intertidal zone

p.43: Trumpeter swans on Sandhill Creek
p.44: Indian paintbrush, south end of Vargas Island
p.45: Driftwood window on Clayoquot
p.46: Bald eagle on driftwood roots, Long Beach
p.47: Squall, Long Beach
p.48: Sanderlings at Long Beach
p.49: Patterns in sand, Sandhill Creek
p.50: Great blue heron at dawn
p.51: Morning sun at Cox Bay
p.52: Red columbine flower
p.53: Sunset from northwest end of Long Beach
p.54: Heavy winter weather, southeast end of Long Beach
p.55: Sand dunes in snow, Long Beach
p.56: Whimbrels in flight, Long Beach
p.57: Sand dollars, Medallion Beach
p.58: Moon snail with evening light reflected in wet sand
p.60: Nootka Rose, *Rosa nutkana*, Long Beach
p.61: Large driftwood, south end of Vargas Island
p.62: Indian paintbrush and beach peas, Sandhill Creek
p.63: Snow bunting in sand dunes, Stubbs Island
p.64, 65: Evening light reflected in wet sand
p.66: Bald eagle at sunset, above Sandhill Creek
p.67: Early morning on Megin Lake, Strathcona Park
p.68: Whaler Island on a summer evening
p.69: Moon rising over Clayoquot Sound, seen from Kutcous Point at dusk
p.70–71: Clouds after a winter storm, Chesterman Beach
p.72, 73: Waves at South Beach, Pacific Rim National Park
p.74: Tree roots lit up by evening sun, Chesterman Beach
p.75: Sun sets behind Tree Island, south side of Vargas Island

p.76: Evening sky and Flores Island seen from Vargas Island
p.78: Sunlight in rainforest, Pacific Rim National Park
p.79: Coastal rainforest in mist, Vargas Island
p.81: Sitka spruce grove, Meares Island
p.82: Driftwood on beach, southeast side of Flores Island
p.83: Dune grass, Stubbs Island
p.84: Edge of the tide, Long Beach in winter
p.86: Western sandpipers land on Long Beach
p.87: Morning sun, Sombrio Beach
p.88: Driftwood in dunes, southeast end of Long Beach
p.89: Breaking wave lit up by setting sun, Wild Pacific Trail, Ucluelet
p.90–91: View from the top of Radar Hill, Pacific Rim National Park
p.92: Sword ferns on tree roots, Vargas Island
p.93: Rainforest in mist, Vargas Island
p.94: Western red cedar in Meares Island rainforest
p.95: Cougar in tree, Tofino
p.96: Frost on sedge, Sandhill Creek
p.97: Meares Island in snow
p.99: Sunset at Chesterman Beach after winter storm
p.100: Surf rolls ashore at Chesterman Beach
p.101: Winter squall, South Beach
p.102: Rainbow skies seen from Medallion Beach
p.103: Rainbow skies reflected in wet beach sand
p.104: View of Frank Island from Chesterman Beach
p.105: Driftwood roots, south end of Vargas
p.106: Bald eagle soaring
p.107: Evening sky seen from Vargas Island looking west
p.109: View of the sound at dusk from Flores Island

Acknowledgements:

Before thanking and acknowledging the holders of copyright of the various quotes, I want to thank several friends for their encouragement in bringing this book to completion. Thanks to Michael and Carol Foort for their encouragement when the book was still in its infancy, and thanks to Helen Clay, Michael Mullen and Gay Browning for their encouragement and help in making it happen. Thanks as well to the folks at Harbour Publishing.

p.5: *"I hope you won't bother your heads about happiness. It is a cat-like emotion; if you try to coax it, happiness will avoid you, but if you pay no attention to it it will rub against your legs and spring unbidden into your lap. Forget happiness, and pin your hopes on understanding."*
from "What Every Girl Should Know" in *One Half of Robertson Davies* by Robertson Davies, copyright © 1977 by Robertson Davies. Reprinted by permission of Viking Penguin, a division of Penguin Group (USA) Inc and Penguin (Canada).

pp.5, 35, 54, 83, 87: *I Ching* quotations are from *The I Ching, or Book of Changes, 3rd Edition*, by Wilhelm Richard. Copyright © 1950 by Bollingen Foundation Inc. New material copyright © 1967 by Bollingen Foundation. Copyright © renewed 1977 by Princeton University Press. Reprinted by permission of Princeton University Press.

pp.5, 10, 47, 66, 79, 86, 93, 104: Albert Einstein quotations are from *The New Quotable Einstein* by Alice Calaprice (Editor). Copyright © 2005 Princeton University Press and the Hebrew University of Jerusalem. Reprinted by permission of Princeton University Press.

pp.6, 36, 48, 51: Lao-tsu quotations are from *Tao Te Ching: A New English Version*, by Stephen Mitchell. Translation copyright © 1988 by Stephen Mitchell. Reprinted by permission of HarperCollins Publishers.

p.11: *"If a man wants to be of the greatest possible value to his fellow creatures, let him begin the long, solitary task of perfecting himself."*
from *A Jig for the Gypsy* by Robertson Davies. Clarke Irwin, Toronto, copyright

© 1955. Reprinted by permission of The Cooke Agency, Toronto.

p.14: *"...he not busy being born, is busy dying."* from the song, "It's all right Ma, (I'm only bleeding)" by Bob Dylan. Copyright © 1965 renewed 1993 Special Rider Music.

p.25: *"...the Paradise which our preachers are always locating here and there out of reach..."*
from *Zanita: A Tale of the Yo-semite* by Thérèse Yelverton, Hurd and Houghton, New York, 1872.

Harbour Publishing Co. Ltd.
P.O. Box 219, Madeira Park, BC, V0N 2H0
www.harbourpublishing.com

All photography by Adrian Dorst
Cover design by Anna Comfort
Text design by Roger Handling, Terra Firma Digital Arts
Printed on 10% PCW recycled stock using soy-based inks
Printed and bound in Canada

Harbour Publishing acknowledges financial support from the Government of Canada through the Book Publishing Industry Development Program and the Canada Council for the Arts, and from the Province of British Columbia through the BC Arts Council and the Book Publishing Tax Credit.

Library and Archives Canada Cataloguing in Publication

Dorst, Adrian
 Reflections at Sandhill Creek : meditations on the wild west coast / Adrian Dorst.

ISBN 978-1-55017-474-8

 1. Pacific Coast (B.C.)—Pictorial works. 2. Natural history—British Columbia—Pacific Coast. I. Title.

FC3845.S28 D67 2009 971.1'1050222
C2009-900883-1

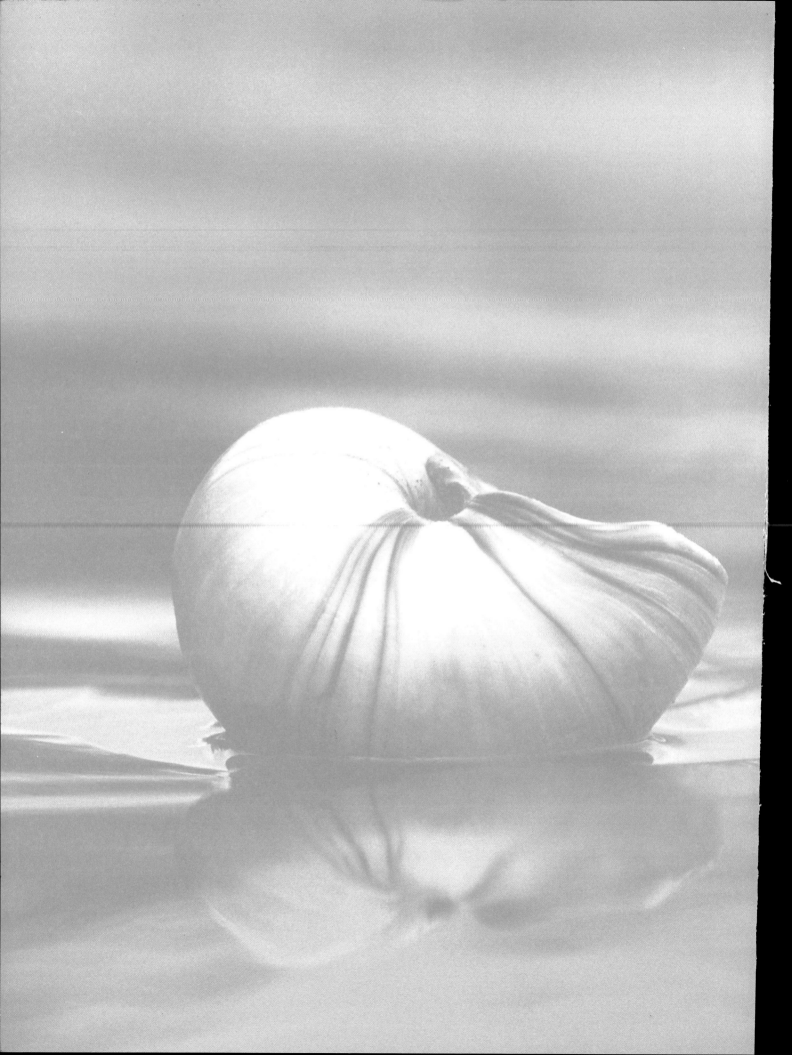